PRINTS
GALORE

PRINTS
GALORE

THE ART AND CRAFT OF
PRINTMAKING

Angie Franke

4880 Lower Valley Road • Atglen, PA 19310

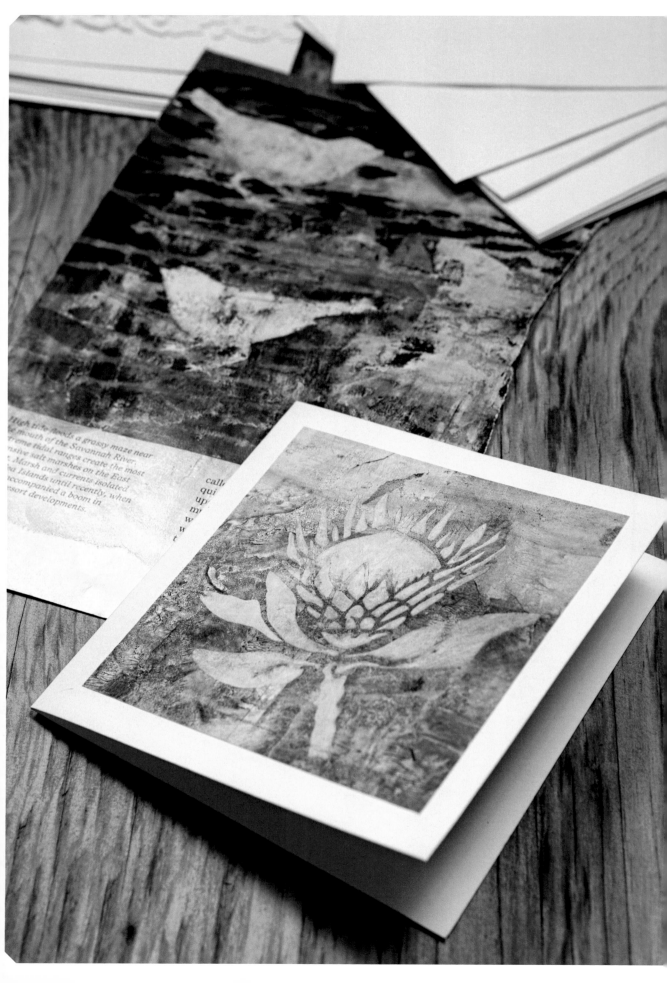

CONTENTS

Right: Marks left by a hose on wet cement

WHY PRINTS?

We are wired to make prints

We begin our lives being imprinted, we make our marks as we grow and eventually leave impressions—good or bad—as part of our being on the planet, no matter whether a few minutes after birth or more than 90 years. All nature leaves marks too, from ancient fossils recording archaeological impressions to ephemeral traces of transient tidemarks on a pristine beach—and my elderly cat who deliberately left his feline paw-prints across a newly-cemented floor: a marked expression of his dogged personality!

Everything we see, read and enjoy has been printed, is linked to printing or is being imprinted on our brains—positively and negatively. Activists try to focus awareness on our destructive "human footprint" but most of us prefer to appreciate the beauty or intensity of our physical or spiritual traces and effects. Artists, particularly, are on a mission to impress—in all ways—with the marks we make deliberately. When art and activism come together, people become more sensitive to the imprinting and expression of burdens and beauty.

Intention is the driving force behind mark-making and printing, whether conscious or casual. For eons, artists have added value and dimension to our knowledge and appreciation of life by recording, mark-making and visual commentary: from age-old handprints on cave walls to chiseled recordings on rocks; from illuminated manuscripts and historical printing presses to 3D printing—producing anything from foods to prosthetics from materials as diverse as seaweed and steel. We are wired to make prints!

However, we're immersed in an age of instant gratification where touches record our tracks digitally—and printing happens with just a click from our screens. We need to refocus on our personal, physical and creative desires as a balance to recording "selfies" and other personal information without thinking. More and more people are turning to manual print- and mark-making to satisfy artistic urges with hands-on color. We all enjoy manual, not mechanical or digital, involvement, although the latter are useful tools for experimental printmakers.

Physical printing is so simple, easy and satisfying. Print-making bridges the gap between art and craft. Working with our hands and right-brained activity balances all our left-brain intensities and stress. It's a recipe for good health and happiness with only one mental health warning: these processes are addictive!

I urge you to make your own impressions.

PRINTING . . . IS THE PRESERVATIVE OF ALL ARTS
ISAIAH THOMAS

HOW TO USE THIS BOOK

This book explores deliberate mark-marking to create interesting and beautiful printed effects. From simple stamping to unique monoprints, textured, layered and detailed art prints to serendipitous nature prints, you will be inspired to make your own marks using these methods as you see how easy it is to overcome fear of a blank surface and let your creativity take form.

Starting with the most basic of personal prints, the book works through easily accessible techniques that do not require specialist equipment such as printing presses, metal or lithographic plates and expensive tools. It explores the basics of relief and recess printing and the crossover between them, many monotype printing processes and some transfer and natural printing effects.

With the wealth of media and materials available, there are many types of printing opening up—the problem is deciding which to use! In our previous books, my coauthor Monique Day-Wilde and I covered a fair number of printing and transfer techniques with paper and fabric. So rather than repeat our previous work, I have various options and offer a range of interesting approaches across a diverse assortment of easily obtainable resources.

Many small projects from the beginning of the book can be used in subsequent printing methods as the book builds on ideas. You will see crossover and layering possibilities in all the techniques—especially in gel printing, which is the most versatile method open to the home printer who does not have access to a rolling press, book press or screens.

Included are recipes for making inks, printing pads and plates, suggestions for what to print on and alternatives to traditional tools and processes.

Though we are fortunate that we can shop online from anywhere in the world, accessing excellent, affordable art supplies takes time (not to mention erratic postal services, foreign exchange rates and import duties). When the muse moves you to create, you need to be ready, or risk losing the enthusiasm of the moment that creates art! This takes planning—or resorting to substitutes. So, to ease the process, I have done a lot of that here for you.

Printmaking is a vast arena of techniques, each requiring differing and sometimes very specific tools and materials. It would confuse (and bore) you to list them under single generic titles such as "Equipment" and "Procedures" before you get to the fun of trying some printmaking. Therefore, each section of this book has its own explanations, instructions and hints, and each project has its list of requirements.

For further information about color, copyright issues, general printing advice, registration, reading and a glossary of terminology, flip to the last quarter of the book. For now though, I want us to jump in with both hands (literally)—we've got so much printmaking to explore!

EDUCATION IS WHEN YOU READ THE FINE PRINT; EXPERIENCE IS WHAT YOU GET WHEN YOU DON'T

PETE SEEGER

PERSONAL PRINTS

There's no excuse for not having tools with which to print—hands and mud are always available. So too are other body parts, together with chocolate, lipstick, face paint and other such items, which make interesting "ink"! So get creative with your body and allow your children to explore their hands, mouths and footprints. These are always appreciated for posterity. A fantastic gift for a child's coming-of-age celebration would be a time capsule, containing your baby's prints . . .

WE'RE ALL THUMBS

Let's start with our personal identifying mark—which distinguishes us from almost the entire animal world—our thumbprints. And to get the digital thing dealt with, we will blow these up with the press of a button—easy peasy! We're actually **not** all thumbs when it comes to printing: fingers, feet, toes and noses make good prints too!

YOU NEED

Thumbs (yours, a significant other's or both)

Black stamp pad (bought or make your own: see Recipes)

White copy paper

Digital copier capable of enlargement (home or at a print shop)

Backing board, block or frame to display your print

Wallpaper glue and brayer (optional)

1. Press your thumb lightly onto the stamp pad and check that the color has coated it evenly.

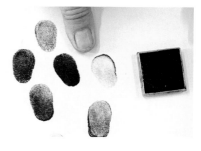

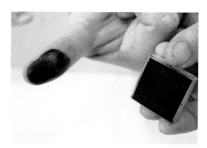

2. Now press your thumb onto paper and check the impression. Repeat until you have a nice clear print—this may take several attempts. Decide what size (or section) to print and then take your chosen prints to the copier and enlarge them.

3. Frame or paste them onto board using wallpaper glue and a brayer. Sign your print with your thumb in contrasting colored ink.

IF YOU DO BIG THINGS
THEY PRINT YOUR FACE,
AND IF YOU DO LITTLE
THINGS THEY PRINT ONLY
YOUR THUMBS

ARTHUR BAER

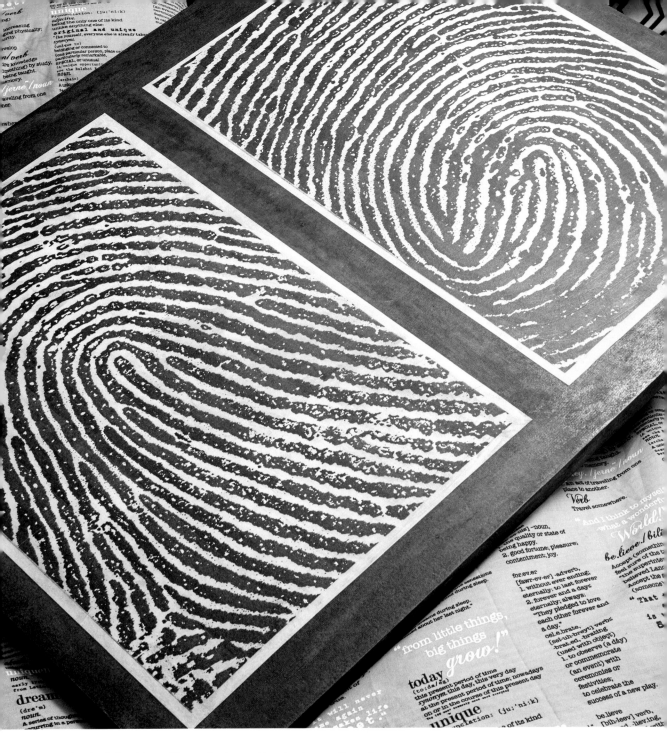

Two poster-sized prints—his and hers—look good in a bedroom. Or make a collage of small blocked prints of all your family's thumbs. The clean minimalist look of high contrast prints doesn't suit my home, so I decorated the cover of something else we spend time thumbing through—our telephone book. I scanned and printed the thumbs onto fabric that had been ironed onto freezer paper and run through my laser printer. Try this as quick wall art and share a pic on our Schiffer Books Facebook page—we'll give you a "like"!

MORE IDEAS

Stick out your thumb (below)

Cover laser or photocopy toner thumbprints with stamping foil and iron with a hot, dry iron (heat causes foil to stick to toner), then rip it off to reveal your foiled print. For contrast, use dark paper for the enlargement (even if it's hard to see where the toner has printed). Alternatively, feed the print and foil through a laminator (without plastic film) or trace lines with a glue pen, allowing it to dry to a tacky consistency before foiling.

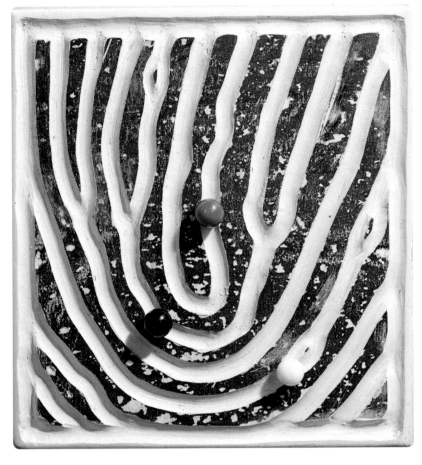

Thumbs down

Use a ballpoint pen to heavily trace print lines onto fun foam, making a large "embossed" thumb stamp. Ink, print and emboss with pearly powder or flocking for a fuzzy feel. You could also blob colored silicone sealer (mix red acrylic paint 1:1 with silicone) onto a surface, wet your thumb and press it into the blob to create fake sealing wax.

Twiddle your thumbs (above)

Trace a section of an enlarged thumbprint onto freshly dried plaster. Gouge out grooves to produce a finger labyrinth, adding ball bearings or marbles to make an intriguing desktop puzzle.

Thumbs up mural

Print your thumb onto a clear transparency and project it onto a blank wall (or ceiling) with an overhead projector—or scan and use a data projector—then trace with a pencil. Paint the tracing with multiple colors for maximum effect!

CAUGHT RED-HANDED

Finished thumb-printing? Now give yourself a high-five with paint on cloth. Nothing says "work" like an apron—they come in handy for keeping your clothes clean, and the pockets store tools in easy reach of your hands. So why not impress everyone with your handiwork?

YOU NEED

Apron with a pocket—wash and iron before printing

Fabric paint on a polystyrene palette—I used black and opaque red

A soft sponge (kitchen or bathroom will be fine)

Iron and ironing board

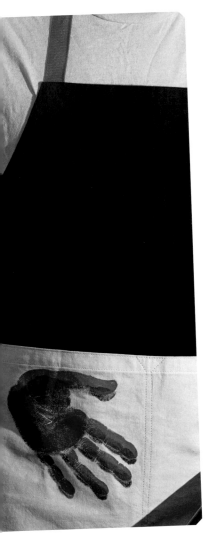

1. Don your apron and tap the sponge in paint until it is absorbed into the surface (it should not be wet or slick-looking). Now tap the painted sponge onto your **other** hand until it is evenly coated.

2. Press the painted hand into position on your apron and hold still for a few seconds before lifting it off carefully and cleaning your hand. If you prefer, you could print the apron on a padded printing surface but "real" effects are more interesting than perfect ones. I used black ink to press a "shadow" print.

3. Now repeat the process using the opaque red over the first print— slightly to one side—to create a 3D shadow effect. You may need to reprint this second print to make it stand out more. It's easy enough to do—simply line up your fingers and palm before pressing down.

4. Use a hot iron over the dry print to make the apron washable. Leave the print for a few days to settle before washing. Add children's handprints as personalized gifts for grandparents or Mother's/Father's Day. Use opaque paint if the apron is made from dark cloth or to cover other prints; transparent paint if the cloth is light or for blending overlapping prints.

IN THE CENTER WAS A TINY
HANDPRINT IN RED PAINT

J.R. WARD

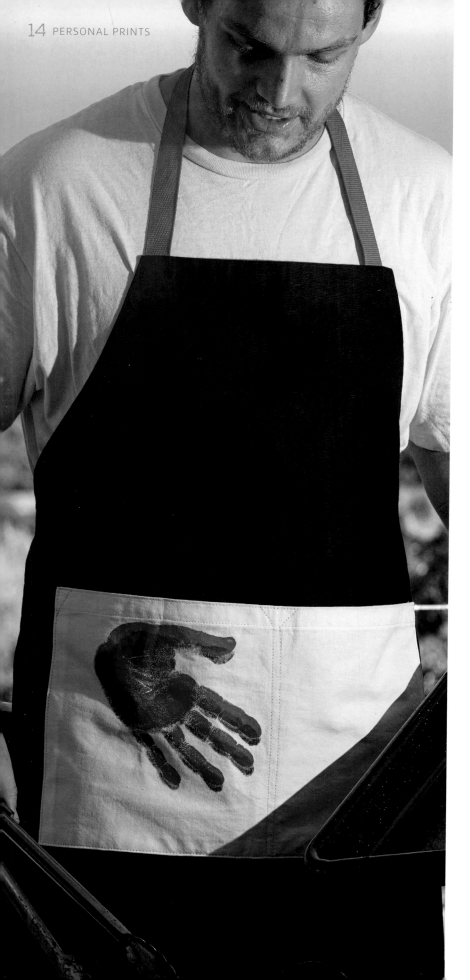

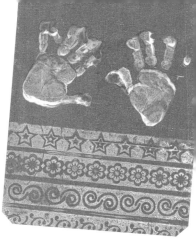

MORE IDEAS

On the one hand (above)

Using non-toxic, washable paint, print your baby's hand onto plain paper and make copies as thank-you cards, or as an imprint for a journal or time capsule. Be patient: babies ball their fists when paint is tapped onto them. If your baby is relaxed, this is easy, if not then wait until they are sleeping soundly and work gently and quickly. Otherwise, make footprints—much easier!

On the other hand

Print your and your partner's hands side by side for a special hand-in-hand memory piece, album cover, framed artwork for the office or anniversary card or invitation (reduce the print digitally and make copies to stick on cards).

Get all hands on deck

Create a family tree with each person's hand printed on individually signed cards with messages, and hang them from a branch for a family occasion.

Hand it over

Personalize a duvet cover or quilt with handprints. This is a good one to get the kids involved with as they will treasure it as an heirloom one day. Over-dye to bring the colors together—fabric paints resist dye beautifully.

STAMP PRINTS

As a child I was confused by the word "stamp." What did stamping my foot have to do with sticking a stamp on an envelope, or the library assistant date-stamping my book? I soon realized that stamping is the simplest form of printing—ink and press! Results will vary depending on the stamp, ink, surface and application.

Some useful tips for using stamps (and texture plates) are:

- Use a small raised pad, sponge or brayer to apply ink evenly onto large stamps that don't fit onto conventional ink pads.
- Before pressing an inked stamp, hold the surface to the light to see if all the raised parts are evenly covered. Re-ink stamps if necessary.
- If the stamp pad dries, lightly mist it with a spray of water, add a few drops of glycerin or re-ink with the correct ink.
- Cover hard or uneven work surfaces to ensure a good result. Use a pad of old papers, a sheet of felt, or fun foam underneath a printing substrate (the surface to be printed) to create "give" when stamping.
- Practice "pulls" on scrap paper. Press evenly on all parts of the stamp, including the middle. If you move or slide a stamp, it creates a 3D smudge.
- If a stamp (for example a carved block) is too large to apply even hand pressure downward, place it on a flat surface, **inked side up**, and lay the paper or fabric (substrate) on top. Use a spoon, brayer or baren to rub the back of the print as evenly as possible without shifting it. Hold the print in place with one hand and lift a corner with your other hand to check the print. Re-lay the paper or fabric and keep rubbing and checking until you're satisfied.

NEARLY ALL OUR ORIGINALITY COMES FROM THE STAMP THAT TIME IMPRESSES UPON OUR SENSIBILITY

CHARLES BAUDELAIRE

Right: An antique, etched metal stamp found in a junk shop. It still prints perfect images for that vintage look—shoes have come full circle!

FOUND AROUND STAMPS

Simple objects, from grocery items to footwear, provide a wealth of printing supplies and make detailed prints when combined and layered. Open your eyes to possibilities: decorate clothing, bedding, paper and cards—even walls and setting cement—using suitable found objects just as they are (or with slight modifications). Look at household oddments with discerning eyes. I use silicone icing mats to print filigree patterns on paper bags to hold my handmade soaps—they also emboss the surface of the soap (I line my soap molds with filigree mats cut to size). See pages 28 and 41 for instructions on how to make a silicone stamp or texture mat.

Print with plastic packaging, lace table mats, felt cut-outs, car mats, toys and brushes: anything with texture or relief that is not too precious and can be cleaned easily (very important!). Modify objects by cutting into them to create recessed or engraved prints, or use them as bases to add relief, for example, gluing on fun foam shapes, which will give you raised or embossed prints. See Collagraphs on page 42.

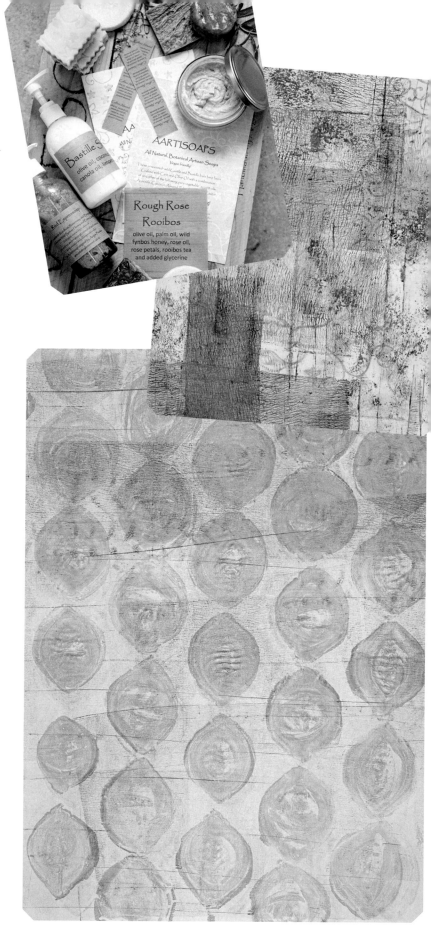

Right: Large bubble wrap used as a stamp on a gela pad

BAG A FISH

The Japanese monoprint real fish by rubbing ink or food coloring onto dead fish and covering them with flexible paper or cloth to lift off perfect fish prints. This is known as *gyotaku*. I don't fancy dead fish eyes reproaching me, so I used inanimate found objects to print a fish instead. Found stamps range from lids to Lego, basket bottoms to bottle tops. Try using a variety—plastic, glass, wood and metal—with different inks and paints to see how they print on various surfaces.

Bev Paverd donated fabric for my dyeing and community projects, so this "puffer fish" is a small thank-you gift. To make your own bag, use any printing technique in this book before sewing it together or try these simple effects:

YOU NEED

Fish pattern

Scrunch-dyed cotton fabric

Pencil, chalk or disappearing (embroidery or friction) marker

Metallic and transparent fabric paint

Thread spools, bottle lids and bottoms

Toilet roll tubes—cut and stuck together to make a curvy, layered stamp

4 old bank or credit cards—bent in half and nested securely with masking tape

Opaque and relief (puff) fabric paint

Hair dryer or heat tool

Pearly paint stick (optional)

1. Draw the pattern onto the dyed fabric, tracing the positions of the fish scales, eyes and fins. Use the pencil, chalk or disappearing marker.

2. Stamp transparent and metallic paints with bottle lids and bottoms. Use thread spools to stamp the areas where the fish scales and eyes are marked. Allow to dry.

> THE GREAT THING ABOUT PRINTMAKING IS THAT IT BRINGS THE ELEMENT OF SPORT INTO ARTMAKING
>
> ANONYMOUS

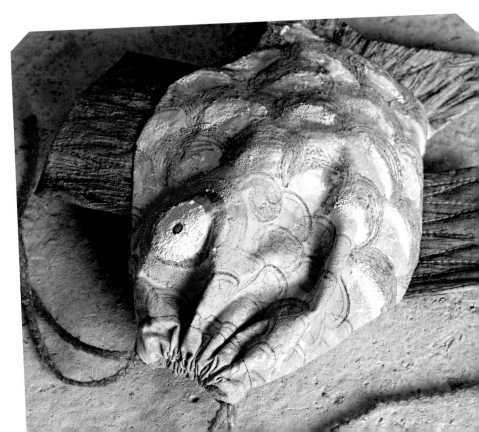

3. Mix relief paint with opaque colors of your choice and print scale outlines and fin details using the cut and taped cardboard tubes and bank cards. Make fine, detailed lines on the bottles, lids and spools in contrasting colors so they show up.

4. Dry the relief paint with heat— because the lines were stamped, the relief paint is not too thick so it forms an embossed texture on the fabric.

5. Relief paint dries matte, so rub raised areas with pearly paint stick (which is permanent) for a lustrous finish.

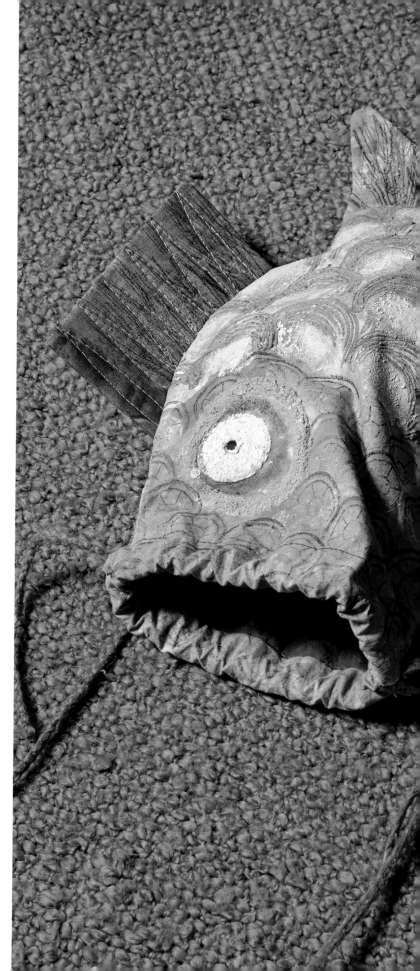

MORE IDEAS

Double duty

Modify blocks (cardboard/wood) by wrapping or gluing thin, even layers of material (or found objects) to them to form stamps, or use double-sided tape instead of glue to hold elastic bands, matches, string, coiled cord or sponge in place. Layer for tantalizingly textural prints.

Draw on waste (below)

Modify disposable polystyrene vegetable trays by using a ballpoint pen to trace designs onto the surface, then ink and print as with any carved stamp. My sisal line design idea came from the plants lining our Eastern Cape country roads. The dried stems make decorative African "trees" and I hang apples from mine for the bird visitors that come to my garden.

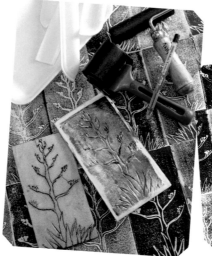

As easy as ABC (bottom right)

Kiddies' blocks make great ready-found alphabet stamps—especially bi-directional letters: A, H, I, M, O, T, U, V, W, X, Y. However, you don't have to be restricted by this because stamping the occasional letter backward makes for a quirky effect. Wood block stamps produce fuzzy, grainy prints as wood doesn't hold much ink and has no "give" when printing. To improve printing, coat wood blocks with a thin layer of tacky glue and, when touch-dry, apply flocking to the surface and allow it to set. Tap off the excess onto a sheet of paper and funnel it back into the flocking container. Ink the wood block and notice the difference in print intensity.

Tread marks

Use trademark treads—shoes, sandals, toy cars, bicycles and even real car tires—to create interesting linear prints. These work best when rolled across a wet painted or plastered surface as they leave negative impressions. It's not easy daubing ink onto the surface of a car tire!

CUT STAMPS

The favorite—temporary—stamp "block" to begin engraving is the potato. It is widely available and lasts a few days if refrigerated, is the right size and shape to grip, contains the perfect amount of moisture to hold and keep inks moist while printing, and is easily cut with ordinary kitchen equipment.

I teach simple stamp cutting and carving techniques to groups very affordably using one bag of potatoes—and cook or compost the leftovers. With careful planning and registration (see Glossary), layered potato prints can be quite sophisticated. I suggest that you explore printing with other cut vegetables and fruits as well (see Botanical printing on pages 118–121).

MR. POTATO HEAD PLAYS CHESS

Our favorite stop in the Langkloof for fabulous coffee, apple-and-bacon pancakes and delicious sautéed potatoes on the side, is The Sweaty Dutchman—also known for his trademark bandana-clad head. He asked a group of us who passed through Kareedouw after a fiber art retreat to create the perfect sized bandana, as commercially made ones were too small for comfort.

I block printed this using potatoes cut into S and D letter shapes—these were my design elements, which were placed in a grid formation (8 x 8). I alternated light and dark layered prints so that the bandana could double up as a portable chessboard as well—I love multipurpose clothing!

YOU NEED

Square of soft, cotton cloth approximately 24 x 24 in. (hem the edges to prevent fraying)

Iron and ironing board

Tailor's disappearing marker or chalk

Ruler

Large potato

Printing paper, scissors and roll of paper towels

Several kitchen knives (large and small) and a vegetable peeler

Permanent marker

Flat, level printing surface large enough on which to tape down your fabric (or use a sticky board—see Work surfaces, page 134)

Tape

2 or 3 homemade stamp pads or sponges

2 or 3 transparent screen printing inks or fabric paints (2 contrasting colors and 1 in between—see Color, pages 126–129)

1. Fold the cloth exactly into "square" quarters and iron lightly. Repeat quarter folding on the diagonal and iron those edges as well. This makes marking a printing grid easier. Mark an 8 x 8 grid in the center, and create a border—using the tailor's pen (or chalk) and a ruler. The ironed lines will be your guide.

2. Cut the potato cleanly in half with a sharp, non-serrated knife. Place each half, face-down, on paper towel to absorb excess moisture. Measure the size of one of the grid blocks and cut a small square paper template to fit it exactly.

3. Use the template to trim each potato half into a matching square. This will enable you to place your prints accurately. Reserve the cut-away bits.

4. Draw chosen designs (in reverse if lettering) onto each potato square using the permanent marker. Carve away the bits you don't want using smaller knives. Be sure to cut **away** from your

THE PATTERN OF HER THOUGHT ON THE CHESSBOARD,
CHARMED ME WARM AGAIN AND THEN SOME
RICHARD BACH

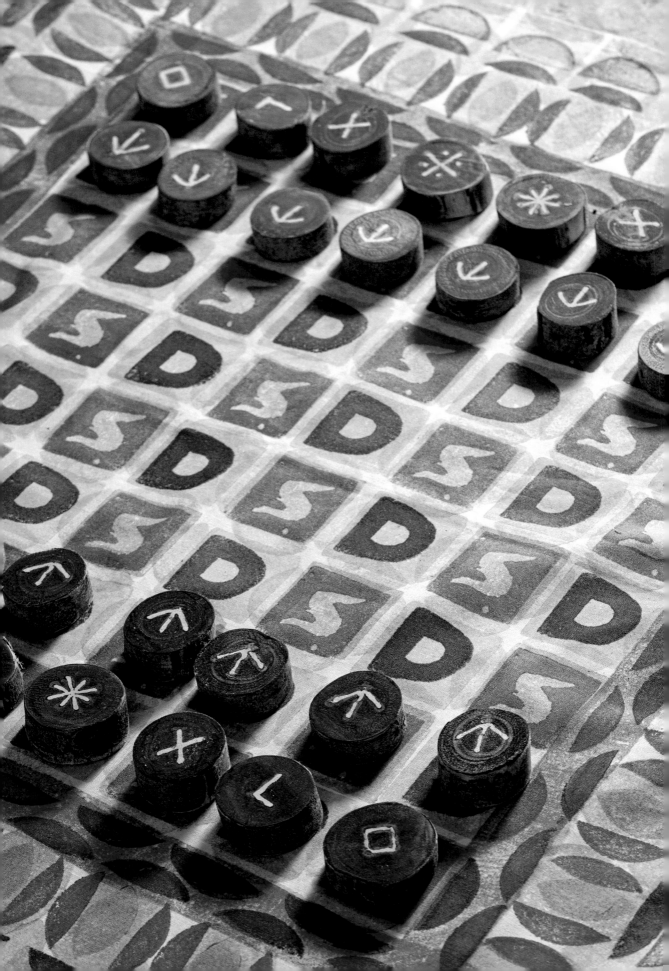

body or fingers when holding the potato. Gouge small holes with the vegetable peeler but ensure that the parts you leave are sturdy enough for printing. If cuts are too shallow, the print may not be "clean," however if they are too deep, the potato surface may be too wobbly and collapse—$^3/_{16}$ to $^3/_8$ inches deep is ideal.

5. Secure the fabric smoothly onto the printing surface. Tap one color lightly onto the carved potato block and pull a few prints on paper to practice. Print the block in every alternate marked square on the grid. Repeat the process with the second color and other stamp. Re-ink the carved surface each time you print. Pull "ghost" prints, to clean the stamp, onto a spare sheet of paper to use as wrapping paper for your finished project.

6. Once the center grid is stamped, use the reserved cut-away pieces to print a border design. Layer transparent colors to build differing shades and tones for a rich, vibrant effect. If you prefer, you could cut a completely new design for the border—after all, it's your bandana.

Let the inks dry before ironing to set them. If you plan to over-dye or need to wash the bandana, wait a few days for the colors to cure thoroughly before proceeding.

MORE IDEAS
Couch potato

Jazz up a cushion cover with striking potato prints. Pop cardboard inside to prevent ink seepage while printing. Children love this kind of printing, but the potato cutting is best left to adults. Simple incisions or punched holes on a wonky potato surface make interesting textural prints.

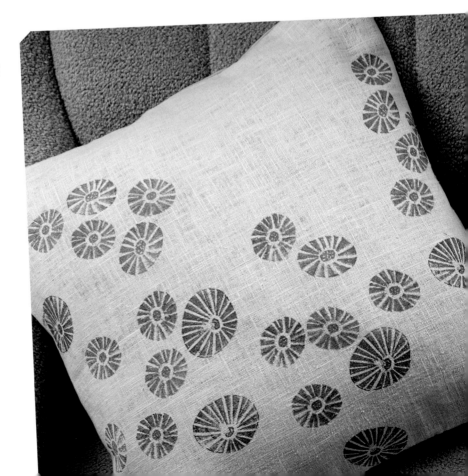

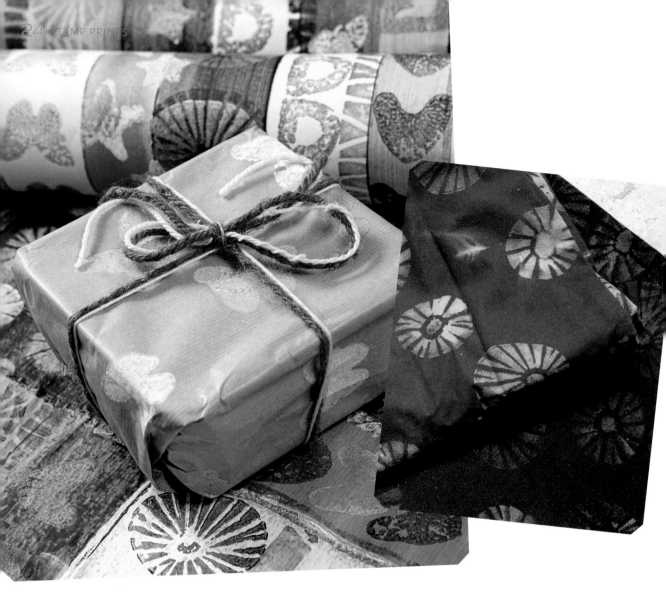

Potato chip (above)

Punch out potato stamps using cookie cutters—it's a perfect way to make gift wrap and cards, and you can fry the off-cuts to munch on while you play! Print blank newsprint or brown paper with random patterns, or layer prints onto blocks of pre-rolled color. This is a good way to practice different printing registrations.

Jacket potatoes (above right)

Disguise accidental bleach spills with potato stamps and a stamp pad made from absorbent kitchen cloth soaked in bleach. Stamp more bleach quickly and randomly over dark fabric and watch as color starts stripping: navy and black usually turn orange, eventually becoming beige as the bleach effect spreads. To halt the process, spray on or immerse the cloth in a mild solution of lemon juice, vinegar or hydrogen peroxide and lots of water (one teaspoon to a quart of water). Finally, wash with soap and rinse well in clean water.

Note: The chemical reaction is quite safe when working with small quantities, but on a large scale, chlorine fumes released from bleach and acids are dangerous. Instead, use commercial bleach stoppers containing sodium metabisulfite or sodium thiosulfate.

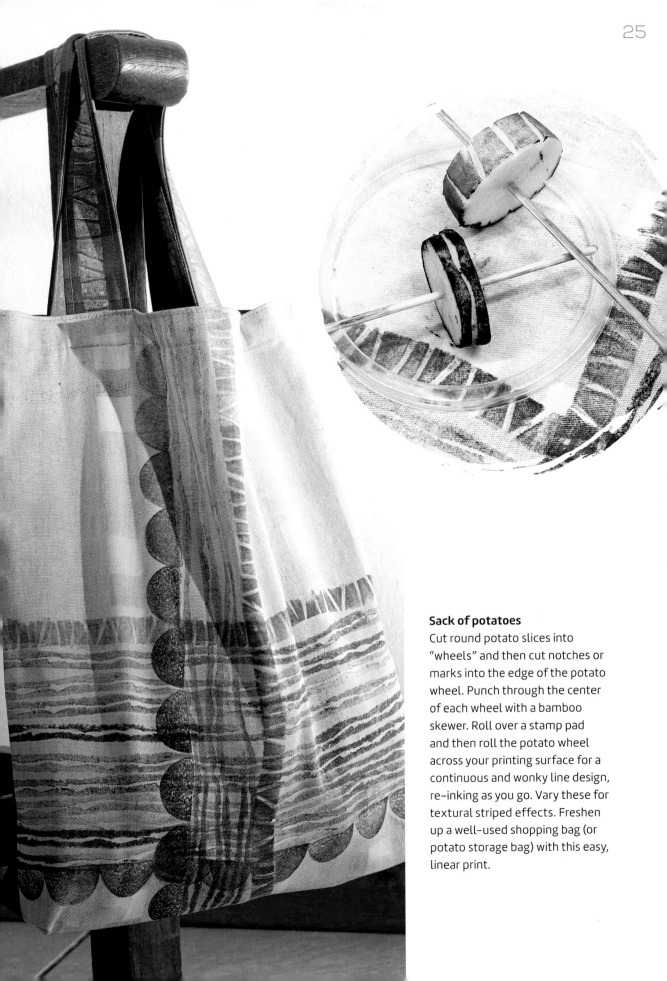

Sack of potatoes

Cut round potato slices into "wheels" and then cut notches or marks into the edge of the potato wheel. Punch through the center of each wheel with a bamboo skewer. Roll over a stamp pad and then roll the potato wheel across your printing surface for a continuous and wonky line design, re-inking as you go. Vary these for textural striped effects. Freshen up a well-used shopping bag (or potato storage bag) with this easy, linear print.

CAST AND MOLDED STAMPS

Cast your own stamps from Gela pad ingredients (see Glossary) or silicone sealer, thinned with mineral turpentine, and poured into cookie cutter shapes or molds. Sometimes it's easier to punch these from a pan of cast gel. Use them as cling stamps with clear acrylic block supports. Mold stamps from a multitude of materials—the simplest being modelling clay. You could also use plasticine, which is reshapeable and ideal when printing various once-off line designs. Make a reusable range of stamps using silicone; self-hardening, cold porcelain (see Recipes on page 137); or polymer clay (bake to make permanent pieces).

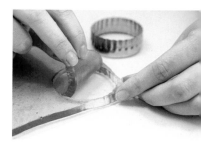

IT'S ALL IN THE GAME

The "bandana chessboard" needed some chess pieces to go with it. As I only wanted to make temporary stamps, I used plasticine to print the chess pieces.

YOU NEED

Modelling clay/plasticine

32 blank "chess pieces" (I used wooden rounds sawn from a branch). Print 16 with darker ink on them to differentiate players

Drawings of line designs for reference

Inscribing tool—a "dead" ballpoint pen or metal ball tool

Printing ink—lino, stamping ink or acrylic paints in contrasting colors that match your board. (I used the same textile inks as for the bandana)

Sharp blade or knife

Brayer

Flat sheet of glass or Perspex big enough to roll ink on

2 sponges

Varnish and brush (optional)

> CHESS PIECES ARE THE BLOCK ALPHABET WHICH SHAPES THOUGHTS
> MARCEL DUCHAMP

1. Roll clay into a "log," with the same approximate diameter as the rounds, and slice into one or more chunky 2-inch sections—it's easier to have a few. Rub the cut sides gently against glass to make them smooth. Draw designs onto the flat surfaces using your inscribing tool, lifting off "crumbs" with a knife point.

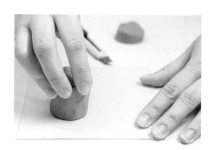

2. Roll ink onto the glass with the brayer, load the sponge and dab ink evenly onto the plasticine surface. Retrace the lines with the tool, engraving them deeper and widening them slightly.

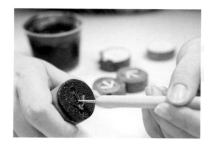

3. Press the inked stamp gently onto a blank chess piece. Repeat for each piece, checking each time that the designs are still in shape. Once you have stamped enough pawns of one team, wipe the modelling clay clean and start the next batch. Varnish when dry.

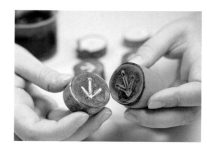

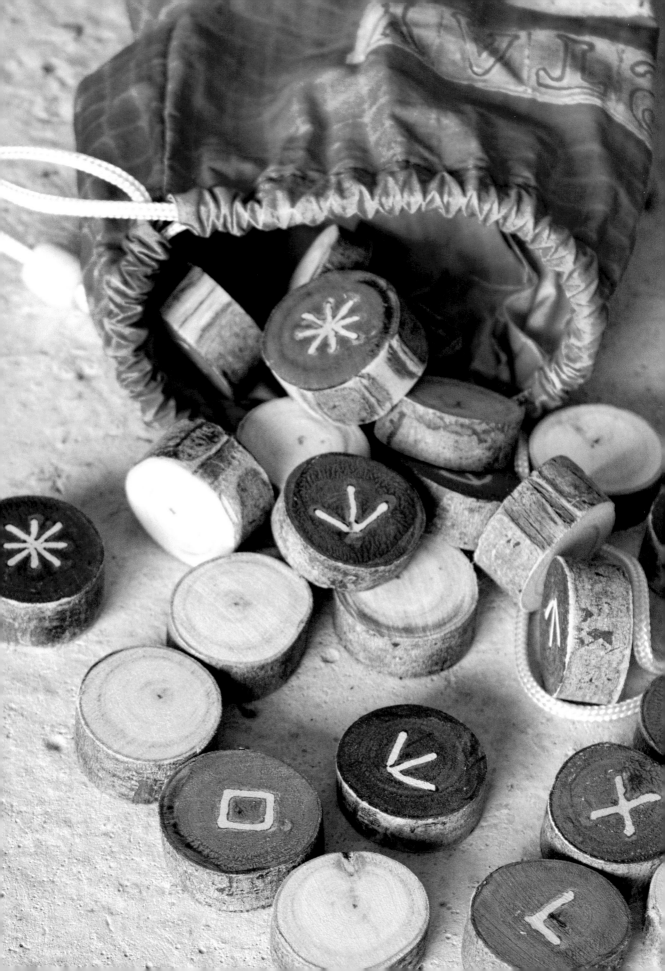

MORE IDEAS

It's in the bag (right)

Stamp cloth at the same time as your chess pieces and make a drawstring bag for storage. Keep the bandana (or a spare) in the bag for picnic chess. I pressed rubber letter stamps onto a slab of plasticine and removed them to create the words. This was printed with the cloth face-down onto the word. Most of the letters can be arranged to read bidirectionally with some creative manipulation, but I kept the back-to-front Ss because they add a quirky touch.

Scrabble magnets/numbers

Print letters onto chunky high-density fiberboard or bisque-fired ceramic tiles using peel-and-stick lettering and high contrast spray-paint. Peel lettering when dry to reveal the wood or ceramic beneath. Spray varnish and glue a magnet on the back to make gifts for game lovers—my Scrabble-addicted neighbour will love these!

Ball games

Flexible clay prints easily onto curved surfaces. I used unbaked polymer clay to print names on pre-painted polystyrene balls for hanging ornaments—the clay is firmer and less sticky than plasticine. Print names or patterns on baseball bats, soccer, baseball or playground balls, or other smooth curved surfaces to personalize them. Use leather stain if the ball is made from natural leather.

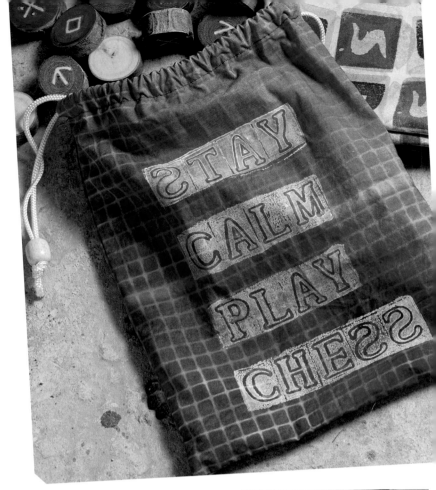

The cat's paw (right)

Thoroughly mix equal parts of acetoxy-curing silicone sealant (also known as caulking—the one that smells of vinegar) with cornstarch to create smooth, non-sticky putty. Press into an engraved, incised or debossed impression that has been brushed lightly with dishwashing detergent. Put a detergent-coated weight on top and leave to cure for 15 minutes. Create a stamp by using it with a clear acrylic block or glue it onto a wooden block with more silicone. You can order custom designs from stamp dealers but they are expensive and it's fun to make your own. I made a perfect kitty paw stamp from our black cat's tracks—now he can "sign" himself the "prince of prints"!

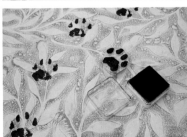

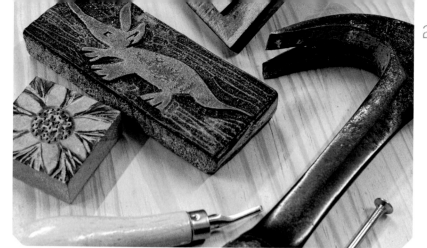

CARVED STAMPS

Carving sounds scary but if you ease into it, using soft materials and a few basic tools, you will gain the confidence to tackle harder blocks. It's a rewarding art in itself and you'll have durable pieces to use for ages.

BLOCK HOUSES

Potatoes make temporary stamps and are not suitable for delicate cutting. The first step to learning finer carving is working with cheap plastic erasers. All you need for tools are a pencil and scalpel-like craft knife. Graduate to curves and fancy patterns once you have mastered the basic groove cut.

YOU NEED

Pencil

Rectangular plastic erasers

Sharp knife

Yellow or white opaque acrylic ink or paint

Sponge

Wooden blocks—angled edges will simulate roofs (the offcut discards at lumber merchants overflow with free pickings)

Varnish (optional)

FUNDAMENTALS ARE THE BUILDING BLOCKS OF FUN

MIKHAIL BARYSHNIKOV

1. Pencil window, shutter, roof-tile and door-frame lines onto three sides of the erasers.

2. Make sharp 30° angle cuts along one side of each line and then the other side. Peel out the cut strips. Cut a cross, using the same method, into the pencil eraser to create round or attic windows.

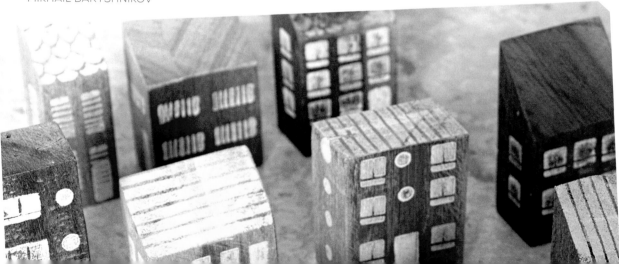

3. Put paint or ink onto a damp sponge, then apply it to the carved erasers and print in varying positions on the blocks. Double up some of the stamps to make longer windows, wider doors, etc. You can varnish your village when done.

Carved wood block stamps were used for centuries as the most reliable way to decorate texts and repeat textile designs. Many museums display a wealth of ancient art materials, patterns and designs. (Visit the British Museum online if you need inspiration.)

Some wood carving steps and tips:

- Choose soft wood with fine, even grain-lines to make cutting easier. Check the softness of the wood by marking a piece with your thumbnail—if it makes a faint impression, it's easy to carve using a craft knife, lino tools or chisel. I inherited many tools from my dad but the three I use most are the small v- and u-gouges and a sharp, pointed scalpel.

- Draw, trace or transfer designs onto wood. Color or mark sections to keep and cut away the rest. Outline the design with the scalpel—using shallow, 45° angled cuts—cutting **away** from the printing edge. This is important: vertical and undercut edges are weak and will break with pressure. These shallow traced cuts will help in the next step.

- Clean out **non-printing** areas with a v-gouge for small spaces or the u for larger ones. Use the v for any cuts **across** the wood grain; the u is easier when working **with** the grain. Practice on scrap pieces of wood. Work safely and keep a first aid kit handy. You will cut yourself if you don't—Murphy's Law of Carving! If you allow children to carve, they must be supervised.

Right: "Crow grain grow"—pages from a handmade, wordless storybook about crows going out to a wheat field at dawn and returning in moonlight: printed with woodblocks, gela pads, texture plates and stencils.

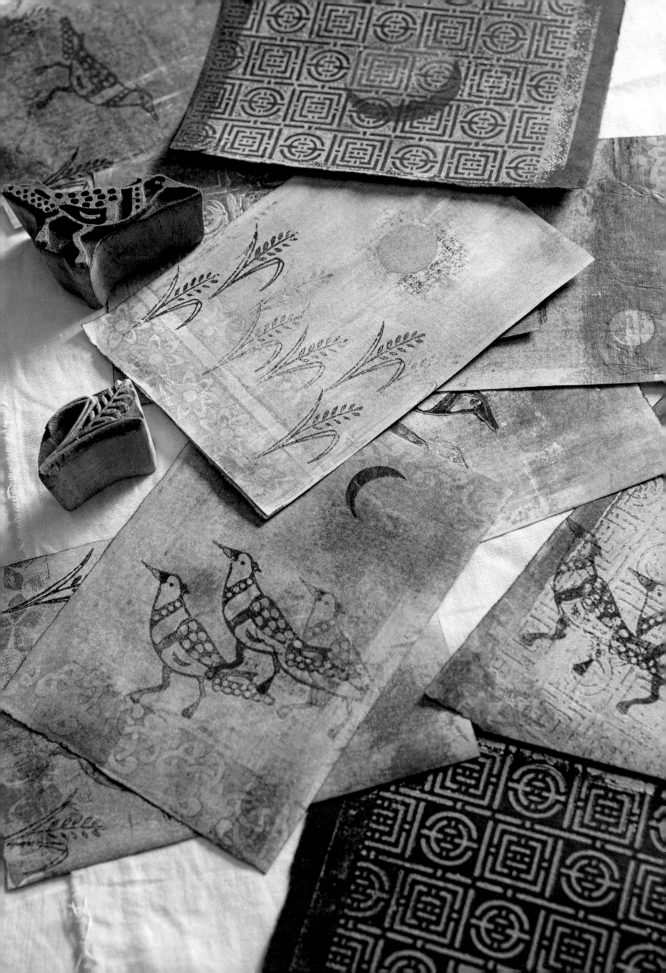

- Support your carving with non-skid matting or, preferably, a bench hook. This enables you to push the block you are carving against the top edge for better control as you carve toward it and **away from your hands** (or any other body part!).

- Carving tools must be sharp—accidents happen when you force blunt tools in frustration. If you struggle to make good cuts, use sharper tools or softer cutting materials. Store blades in covers, or embedded in corks or plastic erasers.
- Carve slowly. Relax. Breathe. Think. Test prints in stages so you don't carve too much material from your block. You can always cut more away, but you cannot put it back easily—although wood blocks can be repaired more easily than rubber or lino. If you need to do a repair job, use wood glue to bond pieces larger than ¼ inch and hold them in place with masking tape for several hours. Live with smaller mistakes (only you will know they are there) or abandon the block. Having said that, I've repaired blocks with putty made from sawdust and glue molded carefully in place before recarving, but you really don't want to do this!

If it all sounds too daunting, just buy wood block stamps or try the following hacks:

En bloc
The simplest of wood block stamps are just blocks—different shaped blocks of even, hard wood can be used to stamp blocks of color for interesting geometric effects, especially for backgrounds and when used for layering transparent colors.

Traditional touches
(opposite page)
I treasure my intricate Indian wood blocks and Ghanaian Adinkra stamps carved from calabash. Find them in antique shops and Oriental markets. Many rural people make a living carving wood blocks and Indian textile "factories" sell worn blocks to art suppliers around the world as collector's pieces. We featured some in previous books. Print as for lino cuts and other stamps, and use them on gela pads.

Fun foam
Create durable, incised or relief stamps on fun foam—much easier than carving into wood! Draw on the surface with ball tools (dead ballpoint pens) to create impressed lines. Or heat and press the expanded foam onto a textured surface or plate and remove. As it cools, it will hold impressions until reheated; then the surface will smooth out, ready for reuse. We used these in most of our other books.

Punchlines
Punch holes to make textured backgrounds for designs on wood blocks using a hammer and nail or metal punch. The more you punch, the stronger the contrast between the smooth, untouched areas and the punched parts of your design will be. Use them to lift texture and patterns off the gela pad, or flock them for direct printing.

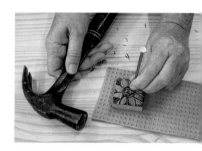

More stamp cheats:
- Die cuts with flocking

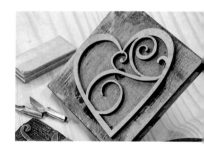

- Fun foam shapes stuck on rollers

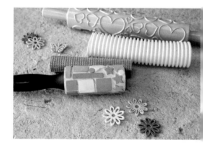

- Puff paint stamped on lids
- Jigsaw puzzle rubbings or pieces glued to blocks

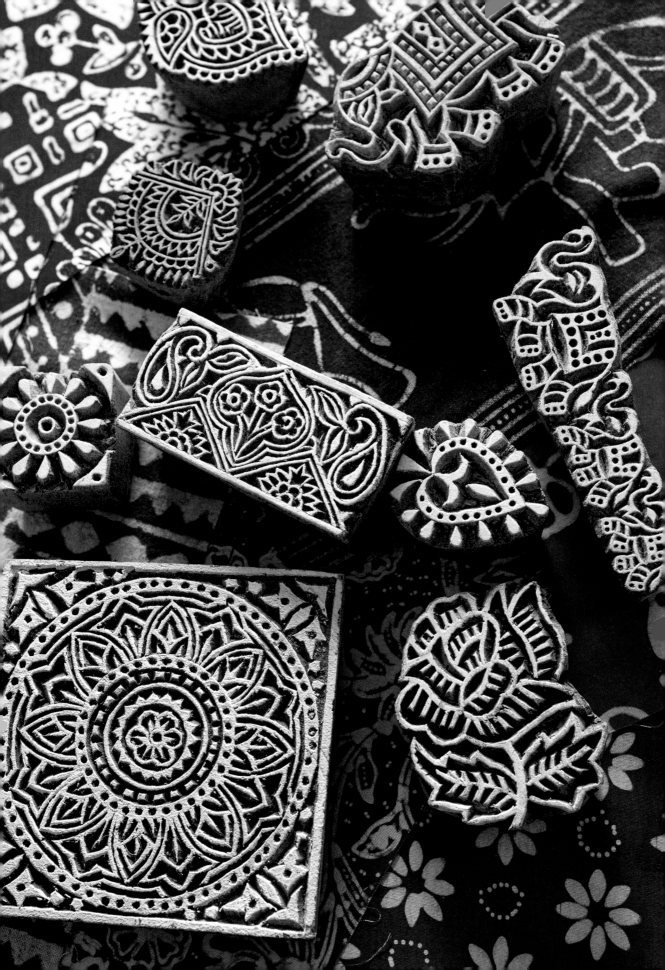

REDUCTION PRINTS

This relief method of printmaking was a favorite of Picasso's as it saved him time and materials. The same block is carved away and printed in layers, enabling a sequence of colors in one print. He didn't have the patience to carve a block per color and would make a hundred prints from each of his blocks in stages (I wish I had just one—a block or print!).

This is also known as "suicide printing": once carved there's no going back. Layers of color and lines cannot be "un-carved," nor can printing be repeated in the same way. I prefer not to spend energy carving anything complicated that I can't reuse, so I adapted Styrofoam (polystyrene) vegetable trays for multicolor reduction printing instead. Soft fun foam is also easily impressed with a pen or ball tool, and both of these cheap, recyclable materials can make a hundred prints or more.

DOTS 'N LINES

A tile-styled stamp is a good project for experimenting with pattern orientations and combinations and can be used to print borders and repeat designs in a myriad of colors. This particular idea comes from a display of ceramic, paper and fabric tile designs printed by school children in an English cathedral.

YOU NEED

Styrofoam (polystyrene) or fun foam

Ball tool, pencil or dead ballpoint pen

Brayer or sponge

Inks

Inking plate

Paper, fabric or chosen substrate

1. Draw a design on paper first. Decide on the number of colors and label different design parts for reference. I used three transparent-based colors: dark yellow, magenta and blue-gray (magenta changes to red when printed over dark yellow). Use opaque inks if you don't want color mixing. The substrate color—in my case paper—adds extra color to your final print. For example, yellow on blue will print green with blue dots showing as the first color.

2. Trace or copy the design onto your print block, remembering to reverse it for text or asymmetrical images, otherwise they will print backward. Turn the block over and mark a direction arrow on the back to assist you with printing placement (registration).

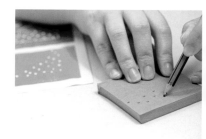

MAKE EVERY MARK COUNT

MAURICIO LASANSKY

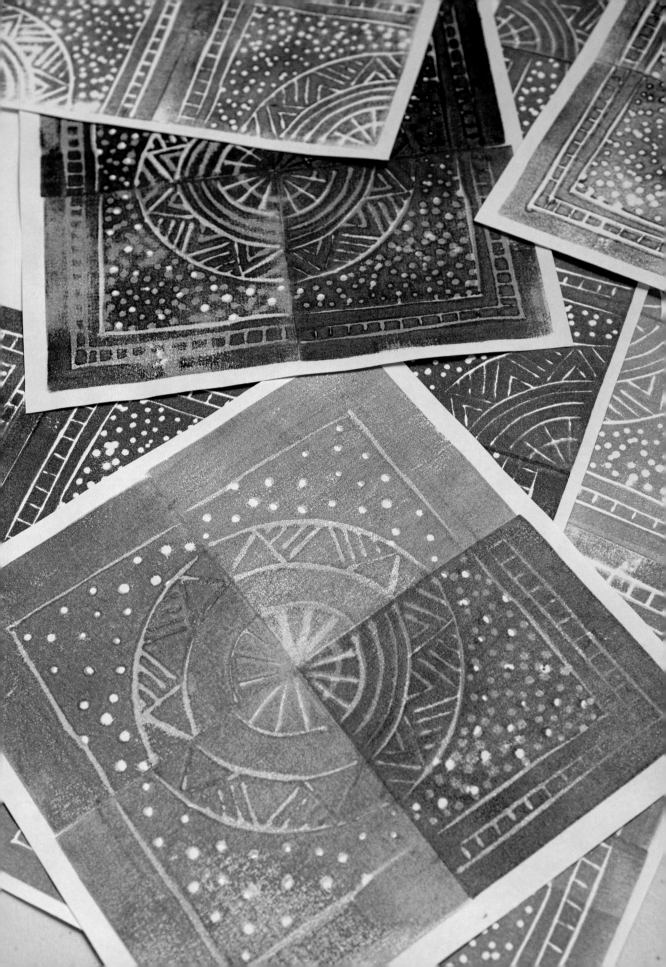

3. Groove or mark the areas of the first color on the printing face of your block using the pen, pencil or ball tool. I made dot impressions to show up the color of the paper (**first color of your print**).

4. Ink the brayer using the first ink color (your **second printed color**). As I was using transparent inks I used the lightest one (dark yellow) first, so the others could build on top. If you're using opaque colors this is not an issue. Apply ink to the block and pull a print. Check that your pressure is even and reapply ink, pulling as many prints as you need. If prints are uneven, re-ink and realign the block carefully to reprint—or leave it a bit wonky for a rustic effect. Once you proceed to the next step, you will not be able to print this color again.

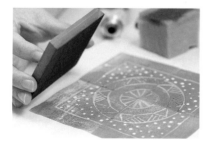

5. Clean and dry the block, then mark or groove the next colored part to be printed around, across or over the first impressions. Ink the brayer and apply the next color to the block, pulling the next round of prints **exactly on top** of the first prints. Geometric shapes are easy to register. Always align the block with the arrow pointing in the same direction.

6. Clean and dry the block again and repeat the grooving or marking for the last color design lines. Re-ink and pull the color (I printed dark gray over red), once again aligning the block.

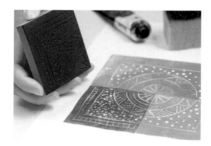

This method can be used for lino, woodblock, stencils, screen prints and collagraphs. Once you are done, this edition of prints is closed as no more multicolored prints can be made in the same way, especially if the colors of your design are carved away more and more from the original block form each time. The final color will have a small surface unrelated to the whole image if printed on its own. Mine works fine as a single print because the block remains whole.

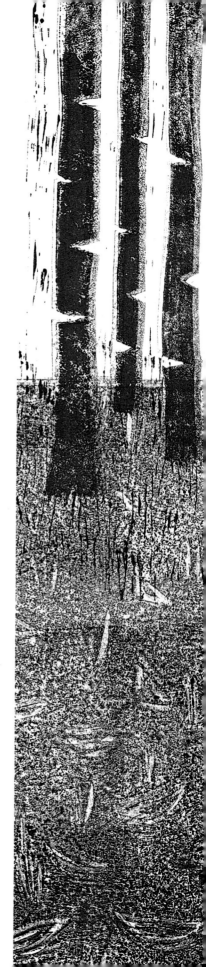

LINO PRINTS

Carve synthetic lino or plastic erasers for larger prints. These synthetic rubbers can be incised a lot easier than traditional lino or hardboard (Masonite—known as "poor man's lino"). They are also easier to clean and don't perish after reacting to ink solvents. Traditional lino and wood cuts were often carved with the reductive method, which breaks my heart! I prefer to cut layers so they can be overprinted and I also pre-print paper using a brayer for an extra layer of color.

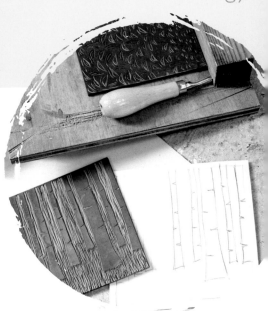

TREE LINES

I used two square blocks to make one rectangular print, although each can be used separately and for a variety of colors. I deliberately overlapped my prints of trunks and leaves as part of the forest design.

YOU NEED

Synthetic lino (or lino, wood or rubber)

Design (chalk, carbon paper or transfer medium)

Ballpoint pen or marker

Bench hook or non-skid matting

Carving tools—a scalpel, sharp v- and a small u-scoop

Lots of paper (copy paper to practice on, and quality, heavyweight paper for prints)

Water, sponge and old towel

Brayers—soft for inking; hard for pressing

Printing ink or paint (thick and sticky)

Metal spoon

Drying rack or wash-line with clothespins

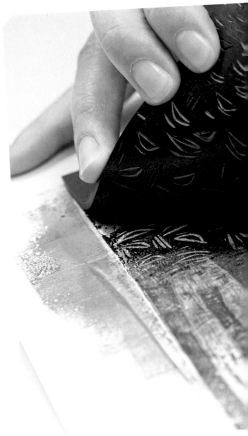

1. Draw or transfer your design directly onto the lino. (You can chalk the back of the design to enable tracing and redraw it with ballpoint pen. Otherwise, photocopies or laser prints rubbed on the back with acetone will transfer detailed prints.) Mark the areas that need to be cut away.

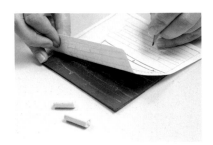

2. Use a bench hook or mat to secure the lino and trace the initial lines with the scalpel. Incise fine grass-like lines using the sharp v and gouge u scoop cuts from

IN A FOREST OF A HUNDRED THOUSAND TREES, NO TWO LEAVES ARE ALIKE

PAULO COELHO

larger areas. Carve away from your body or supporting hand and work carefully. Think before you cut.

3. Sponge both sides of the quality paper with a little water and blot with a towel. Set aside to rest and absorb the moisture until the paper is limp. Very heavy paper (200–300g) needs soaking before blotting. Copy paper (for test prints) needs no soaking or blotting as it will fall apart.

4. Roll ink onto glass with a soft brayer until it is thinly and evenly coated. You need to do this to enable smooth application of ink. Lay the carved lino **face up** on scrap paper and roll ink all over the carved surface.

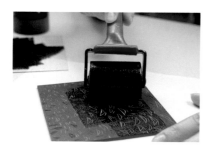

5. Now you have a choice: lift and position the lino face-down on the paper **or** place paper on top of the inked block. If you choose the first option you will need to turn it over. Let the block settle onto the paper, brayer the back of the block gently and then flip it over—**together with the paper**—so that the paper is on top. Once the paper is uppermost, gently brayer the back of the paper to pick up the ink from the block.

6. After you have used the hard brayer over the paper, burnish the back of the print using the metal spoon. Rub gently, in a circular motion, right up to the block edges to indent them for a plate-mark around your print.

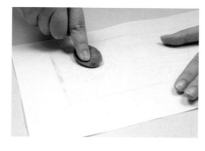

7. Lift the paper off the carving. If you have used good quality dampened paper, it will be slightly embossed as well, adding dimension to your print. Hang your print to dry. Leaving it lying flat is risky unless it is placed in a drying rack—see page 134.

Label, number and sign your prints as you work so that you can show them as an edition (see Glossary).

Use watercolors, or gel crayons to add color (optional).

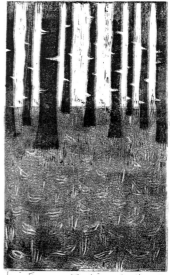

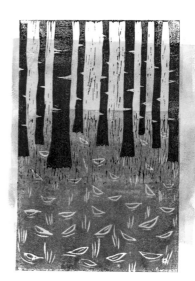

TEXTURE PLATES

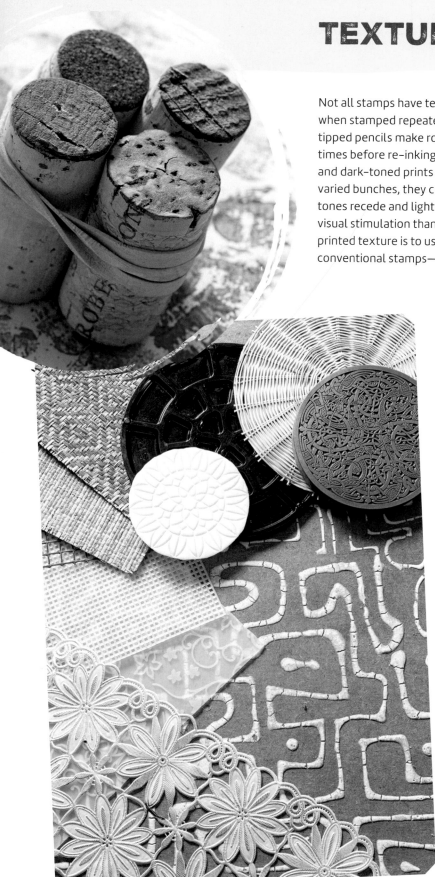

Not all stamps have text or images. Some just create texture when stamped repeatedly—for example, corks or eraser-tipped pencils make round or dotted prints. Printing several times before re-inking will also produce many tones. If light- and dark-toned prints are lightly overlapped or stamped in varied bunches, they create rough or smooth textures. Darker tones recede and lighter ones come forward, creating more visual stimulation than monotones. A quick way of producing printed texture is to use texture plates—these are larger than conventional stamps—ideally, the size of your hand.

• Create permanent texture plates from found objects: stationery and scrapbooking supplies, sewing materials, or things in your grocery cupboard, yard or garage. I collect designer embossing plates, rubbing plates and pewter molds, but often use found objects to print texture—strong veined leaves, rubber car mats, flip-flop soles, sandpaper, wallpaper, netting, lace, embroidered and quilted fabrics, drain covers—anything raised or grooved in a pattern of sorts.

- Make your own simple raised (relief) plates with different glues drawn, dribbled or dropped and allowed to dry on a piece of card or wood. If you want a quicker option, you could also spot, draw or smear glue gun adhesive. Glue also fixes and seals textural elements to plates and PVA; wood glue is the best for both purposes. Glue gun adhesive will adhere as a textural element but it doesn't hold other elements as strongly as wood glue. Starch paste (flour and water mixed until thick, or cornstarch cooked with water) can be drawn with nozzle bottles onto stencil glued supports to make tacky rubbing plates, which double as texture plates.
- Use cardboard (sourced from disposable packaging) and Masonite (MDF) for supports. Try anything suitably sized that can be glued and doesn't need sawing.
- Glue on grains, seeds, beads, buttons, bandages, bottle tops, thread, string, crumpled paper or punched shapes—the possibilities are endless.
- Remember to seal the finished plate with at least two coats of PVA glue if you want it to last, otherwise it will fall apart with pressure or washing.

These are all excellent tools for gela pad and collagraph printing. I prefer to mold my own plates. Maybe it's hereditary as my paternal grandfather was a brass-molder by trade and I still use some

of his tools and books, which are over a hundred and twenty years old! I wish I could have learned from him but at least I have more options than he did when it comes to materials.

Make more texture tools or printing mats from:
- Silicone. Use exactly as for the kitty paw stamp on page 28. Make flexible plates for creating texture on curved surfaces and the gela pad.

- Fun foam (at least ¼ inch thick). Expand with a heat gun or under an oven element and press quickly into textural materials. Allow to cool before checking the relief. If not deep enough, reheat the foam until smooth and press it again onto the texture. This is excellent for gela printing.
- Clay. Roll clay (cold porcelain, polymer or even real clay) evenly, using two identically thick guides (chopsticks or thin dowels at least ¼ inch in diameter) on either side. Spray textural elements with cooking spray then lift and press the clay onto them, or embed them lightly on the clay surface.

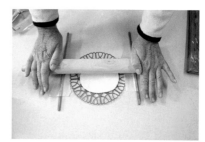

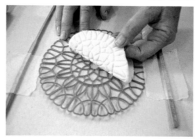

These plates have **recessed relief**, where glued plates have **raised relief**, and make embossed rather than debossed impressions. Leave cold porcelain to harden naturally. Bake polymer clay according to the manufacturer's instructions or use both as temporary plates without hardening if you'd like to reuse the clay. The same applies to potter's clay; if you leave it to dry out as a sturdy texture plate, it can be recycled when you are done by soaking it in water until it's soft and can be reworked and rolled again.

All this texture and relief brings us to the next chapter . . .

MAKE AN IMPRESSION . . .
BE A PRINTMAKER!
ANONYMOUS

COLLAGRAPH PRINTS

Kolla is a Greek word for glue, and graph means drawing. Collagraphy is a relatively modern form of printing, thought to have originated in the late 19th century. Pablo Picasso and Georges Braque coined the term while working with collaged prints. These were dubbed "poor–man's etchings," as printers used card or mount board as plates, rather than copper or zinc.

Collagraphs are just like texture plates, and can be created as incised (intaglio) or raised relief plates. Smooth textures print lighter as more ink can be wiped from them, and rough textures hold ink in their crevices and print darker, in exact imitations of the relief surface on the collagraph plate.

THE POWER OF THE PRESS BELONGS
TO THOSE WHO CAN OPERATE ONE

RUTHANN GODOLLEI

To make your own:

- Glue textural elements **securely** to card or mount board as these take a beating in the printing process. Once glued, cover the plate with non-stick matting, followed by padding (newspapers, blanketing or felt) and top with a heavy weight until completely dry.
- Seal the plate thoroughly. Good varnishing (two coats on the back, front and edges of plates) prolongs the life of collagraph plates, enables successful inking and ensures all textural elements are properly stuck and sealed before printing. Any hard varnish—water- or solvent-based—will enable easy wiping of ink. Shellac dries quickly to form a very tough skin and imparts an antique look to collagraph plates.
- Collagraphs print best using a proper rolling press, but home printers can improvise using a metal spoon, provided the collagraph does not have too great a variation in relief; this would require more pressure than a person's hand can supply to pick up all the ink in the grooves of the plate. I have a small die-cutting machine (Cricut Cuttlebug and Sizzix Big Shot are two popular versions) that I adapted as a mini rolling press; it works excellently for small collagraphs. I've heard of folks using their feet and cars to get great prints, but I'll stick to my Big Shot until I have the money and space for a proper press.
- Print collagraphs on strong, heavy paper that has been pre-soaked. Once soft, it will press into the depressions of a plate and contact all the ink—fine paper may stick to the plate and tear. Smooth fabrics such as calico or percale sheeting are strong and will show up textures perfectly.
- Reproduce collagraphs in many variations of color and mediums on a variety of substrates. These are true monoprints and the plate is a work of art on its own.

Anyone who can glue a collage together can use it to monoprint a collagraph: this method of printing is popular all the way from elementary school art to the most sophisticated fine art. My twelve-year-old nephew in New Zealand sent my mom this shark collagraph, which he printed in school. I have included one relief, one recess and one combination of both collagraph projects for you to explore.

MOUNTAINS IN RELIEF

I used a small collagraph to print fabric designs for notebook covers for our quilters' guild. These can be colored further with Inktense (permanent watercolor dye) pencils and embroidered by machine or hand.

YOU NEED

Design (I used a photo of Western Cape mountains taken from an airplane)

Cardboard—cut up cereal box

Wood glue and glue brush

Scissors or craft knife

Textures—sand, thread, aluminum foil, crumpled paper, sawdust, lace and a needle (to prick tiny dots)

Non-stick silicone baking sheet or toaster bags cut open

Liquid shellac (see glossary)

Printing paper (pre-soaked and well blotted) or smooth fine fabric

Printing ink—sticky printing ink or oil color for the best prints; acrylics dry quickly so use retarders to slow the process. Textile inks and fabric paints work well. Alternatively, print monochrome and color the print afterward with watercolors

Toothbrush or stiff bristle brush

Starched muslin, tissue paper or telephone book pages

Thick padding—newspapers, felt, batting or fabric

Metal spoon, baren or rolling press (I used my manual die cutter)

1. Draw the design outlines onto the card, which will become the printing plate, then decide on textures to fill parts of the design. In my landscape, the smooth aluminum representing the sky contrasts strongly with the sand, crumpled paper, sawdust and lace relief of the mountains.

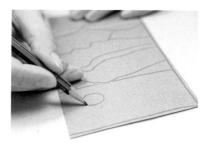

2. Fill each area of the design with glue and the chosen texture for that area. Cut or tear pieces of foil and paper to fit the spaces as you build your plate, and needle-prick fine dots. Leave it to set for a few hours or, preferably, overnight. If textures are very uneven or too raised, cover them with the non-stick baking sheet or toaster bag and place

some heavy weights on top (a pile of books works well) to flatten them as the glue dries. Peel off the sheet once the glue is dry.

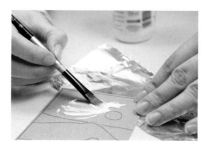

3. Varnish the front, edges and back of the plate thoroughly with the shellac. This step is **extremely** important: apply at least two coats and leave to dry for 24 hours after each coat.

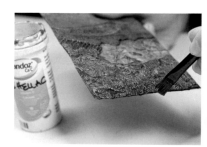

I ROAMED THE COUNTRYSIDE SEARCHING FOR ANSWERS TO THINGS I DID NOT UNDERSTAND. WHY SHELLS EXISTED ON THE TOPS OF MOUNTAINS ALONG WITH THE IMPRINTS OF CORAL

LEONARDO DA VINCI

4. Submerge the paper in warm water and leave to soak while you ink the plate with the chosen colors using stiff brushes. Work inks in very thoroughly. Bear in mind that different colors can be printed off one plate at the same time if you use separate applicators for inking each color.

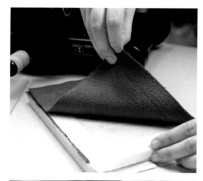

5. Wipe ink off the plate with a balled up piece of muslin or paper. This is the trickiest step in printing: too much ink left on the plate will bleed and smudge; too little ink won't be picked up easily. Practice, practice, practice

7. Remove coverings and peel back the paper or cloth to reveal the print. If paper sticks to the print, spritz it with a spray bottle of water while stuck in position, allowing a minute for the moisture to sink in—it should peel off without any trouble. Thin paper will tear. If you want to print fine papers, stick them onto card for support (see "Chine collé").

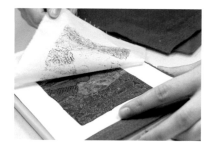

6. Place your plate on a non–slip surface. If using a press, center the plate on a carrier plate (support) to roll through the press and cover with damp paper or dry fabric. Cover again with a piece of felt (if using a spoon) or printing blanket (if using a press). I cut two pieces of polar fleece as "blankets" for my Big Shot. Burnish all over with the spoon, or roll the plate through the press, using as much pressure as possible to transfer the ink.

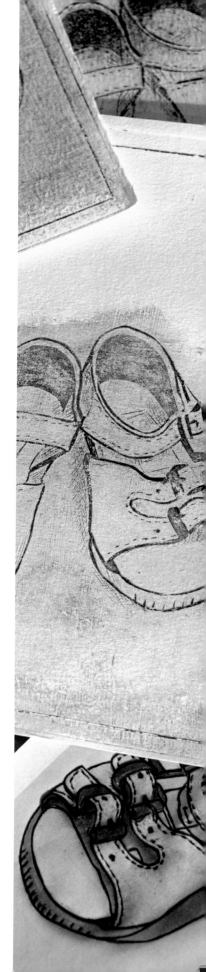

BABY SHOES

My youngest turns 21 this year, and as she is living in the UK I had to think of something special to send her that didn't weigh too much. A collagraph print of her first pair of shoes from her first birthday fits the bill.

 While relief plates are easy and quick to glue together, recessed or "peeled" mount board plates take time, but have the advantage of printing beautiful fine lines. I traced a computer printout of Gemma's shoes directly onto a piece of mount board and used a scalpel to cut the design.

YOU NEED

Design traced onto the back of a piece of mount board

Scalpel

Wood glue

Fine paint brush

Carborundum—if you can't find any, rub two pieces of sandpaper together (fine, medium or coarse grade) or use fine, sifted sand

Sticky tape

Varnish and brush

Ink and toothbrush or rolled felt applicator

Starched muslin, tissue paper or telephone book pages

Metal spoon, baren or rolling press (I used my Big Shot)

Pre-soaked printing paper

O, HERE'S THE SHOE MY BABY WORE, BUT, BABY, WHERE ARE YOU?

DUDLEY RANDALL

1. Score the lines and areas of the design with the scalpel just deeply enough to peel off the smooth mount-board surface layer, revealing the fibrous texture. Smooth card will print lighter and fibrous texture prints darker.

2. Paint wood glue into areas that you want to print even darker and shake carborundum or sand over the glue. Let it dry thoroughly. For very light areas, paint only wood glue and let it set, or cover with sticky tape. This will provide a slick surface for ink to be wiped clean.

3. Varnish all surfaces as for the previous project (see Mountains in relief) and ink, wipe and print in the same way. I used sepia and black oil paints to create antique tones.

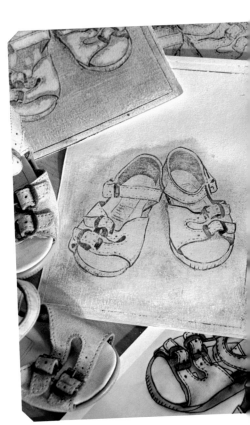

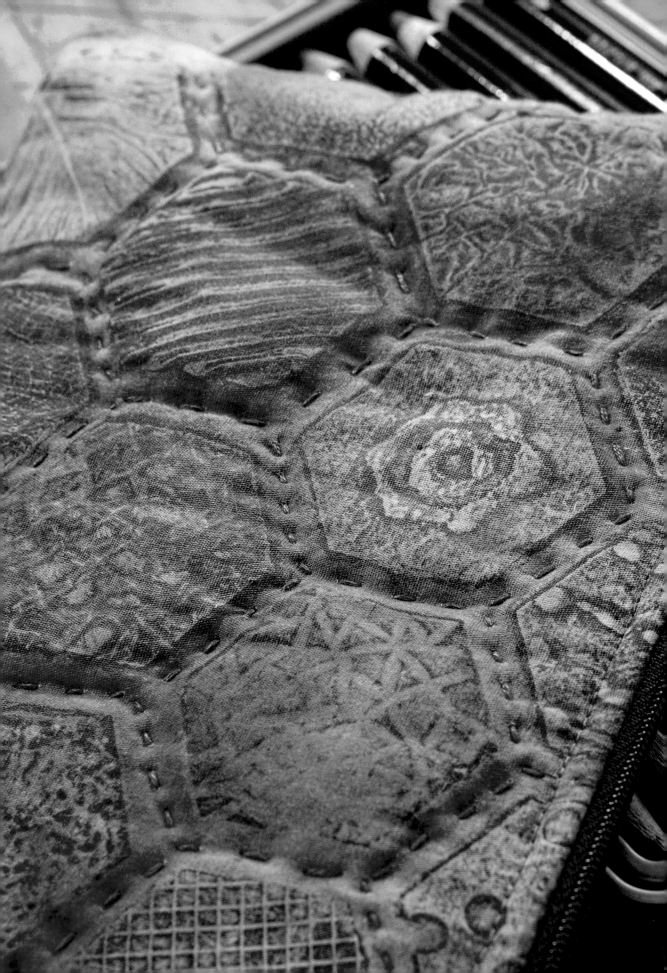

DEAR LITTLE HEXIES

This hexagon "quilt" print, which was fun to put together, combines relief **and** recessed areas on the plate. I cut into the mount-board surface and peeled, flipped and reglued some of the hexagon shapes, with the fibrous surface facing up, adding various textures. The important thing is not to vary the depth of recess and height of relief by more than ¼ in. if you are going to use a spoon or baren for printing pressure. Dampened paper or fabric struggles to pick up detail if textures are too thick.

I used sand, paper doily, corrugated card, crumpled foil, thread, torn paper, glue, bark, plant fiber, masking tape, texture paste, lace, a feather, sandpaper, mesh tape, bandage, onion bag netting, punched shapes and hairy yarn, which were all within my reach, to make interesting prints. I glued and varnished the plate before inking in the same way as the previous two projects. It was exciting to print this and see the results. I tried it on both paper and fabric. Paper took the ink better than the fabric (I used fabric paint for both), so to improve the fabric print I colored it with Inktense dye blocks and pencils and quilted the finished piece by hand stitching around the hexagonal borders.

I aim to experiment more with my next plate, and include burning holes, melting Tyvek (a plastic-type fabric that bubbles with heat) and Lutradur, which also reacts with heat. However, these are scarier techniques and only for the more adventurous with access to odd tools and unusual materials! See what you can come up with. Post the results on Pinterest and tag me please.

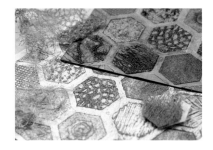

HEXAGONAL TUBES IN A PACKED ARRAY. BEES ARE HARD-WIRED TO LAY THEM DOWN, BUT HOW DOES AN INSECT KNOW ENOUGH GEOMETRY . . .

PETER WATTS

MASK AND STENCIL PRINTS

In printing, a mask blocks out (resists) an area, only allowing color to be applied **around** it but not underneath it. This results in a negative image.

A stencil is a mask with spaces cut into it, which allows (assists) specific placement of color **within** the spaces or openings (windows) to provide a positive image when removed.

Use masks and stencils to apply texture, color, patterns or images, and repeat designs. Create layered effects by using them on gela pads, and in screen and collagraph printing.

I bought a digital scanner and cutting machine to make custom masks and stencils, instead of laboriously hand cutting, as I have done for numerous years. Amazing Asian paper cutters have turned this craft into a higher art form, but you can start with found stencils, for example, lace and doilies, and learn to tear and cut your own.

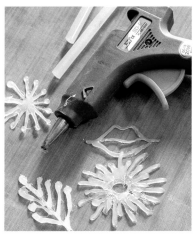

- Check decorating magazines for free stencils or stencil designs. Art shops and the internet are also endless sources—or make your own stencils so as not to infringe copyright laws. When I can't find stencils to fit the ideas in my head, I have to get creative!
- Draw or "write" with a glue gun on non-stick silicone matting and allow the glue to set. Peel this up to use as a unique, permanent stencil or mask—I drew lips, flowers and ferns with my mini-glue gun and used them as masks for spray-painting and gel printing.
- Make masks from torn paper, cut silhouettes from magazine pages or other printed matter; or use any "negative stencil" (the window part cut and removed from the stencil). Use paper, plastic, thread, yarn, tape, clay or fabric as masks. Die cuts from scrapbooking suppliers are ready-made, intricate masks and can be used in reverse. I used magazine images of clothes to recreate my clothes line masks—see Just hanging around on page 72. Reinforce thin paper with contact plastic before cutting the images to make long-lasting negative stencils or masks. File your collection to be used again and again. Edging strips around clay beds or gela pads are good "masks" for making clean "framed" prints. See page 93.
- Make liquid masks from latex, starch paste, gutta and other water-soluble glues, or petroleum jelly for oil-based resists.
- Spray stencils with pressure-sensitive adhesive, or paint them with stencil glue to make them tacky before applying them to printing surfaces—except on gela pads, which hold them perfectly in position. In fact, the gel surface reacts horribly with

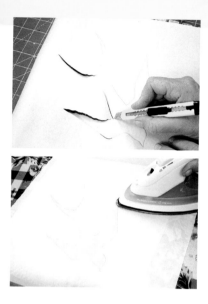

tacky glue, making a complete mess! You could also cut stencils from repositionable contact paper. Iron freezer paper stencils and masks onto fabric for a temporary bond, which prevents shifting or paint seepage.

On the following page is an appealing project which will provide you with unique matching stencils and masks that can be used over a range of projects—particularly with gela pad, screen or sun printing. I make these on my scanning and cutting machine in plastic so I have permanent sets, but cardstock (and even copy paper) will do just fine. To make them sturdier, seal them with varnish or cover with contact paper.

CHEAT WITH FLOWERS

If you have access to real flowers and a scanner/printer/photocopier, you can make your own silhouette stencils. The best plants to use are ones with finer stems which fit under the scanner cover. If you want woodier stemmed flowers—like yucca—take photographs and use those to print your flowers.

YOU NEED

A selection of flowers (I used 8 different ones from my garden)

Paper

Printer/scanner—or go to a copy shop clutching your bunch of plants (most places will humor your request to photocopy flowers if they're not too chunky!)

Pencil and fine black marker

Light box or window pane (optional)

Masking tape

Transparent plastic (acetate) or contact paper

Craft knife and cutting mat—or embroidery scissors or digital cutter

I DON'T THINK THERE'S A . . . BOUNDARY BETWEEN DIGITAL MEDIA AND PRINT MEDIA

BILL GATES

1. Arrange a flower—with stems and leaves (picking off any that overlap)—artistically on the bed of the scanner. Print a black and white copy of your plant, reducing or enlarging the print as desired.

2. Draw around the printed image with the fine black marker, outlining the edges of the shape only. You can cut this as your stencil **or**:

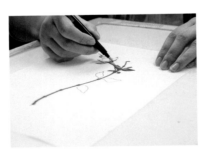

3. Place a clean sheet of paper over the outlined print and hold in place with masking tape then, using a light box or a backlit window pane, trace the drawn lines in pencil for an exact silhouette of your flower shape. Notice the particular characteristics of each flower as you trace it.

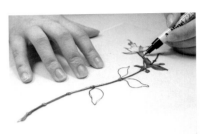

4. Copy the silhouette onto the transparent plastic sheet, or cover the silhouette on both sides with the contact paper.

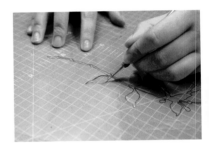

5. Cut the outlines of the design using the knife and mat, scissors or digital cutter. Make clean cuts so that the mask fits exactly into the stencil window, with no jagged or cutaway pieces missing.

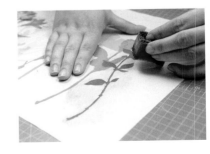

Voilà—a unique stencil and mask!

SPRING SKIES

Use stencil designs and large stamped prints on recycled boxes as unique gifts for crafty collectors. I layered some stencils with graded colors on these as "goodie boxes" for a fiber art retreat held at a hot spring resort. Renovated laptop boxes are ideal for print storage.

YOU NEED

Laptop box or plain portfolio

Primer and PVA paints—turquoise and blue

Sponge roller, a paint brush and some kitchen sponges

Cutwork felt placemat from a home decorating shop

Cloud mask and spring stencil— pre-treated with tacky glue (or cut both from repositionable contact paper)

Water–based varnish

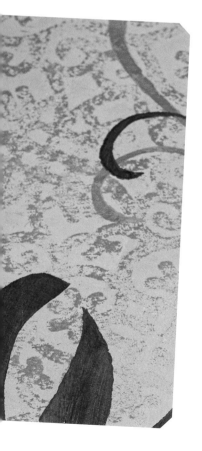

1. Prepare the box by sponge-rolling it with primer followed by two coats of PVA paint to strengthen the cardboard and hide any printed advertising. The turquoise paint will mix with any universal undercoat left in the sponge to create a light turquoise.

2. Wet the felt mat and roll a small amount of blue PVA over it. Press the mat, **paint-side down**, lightly onto the box to print a watery impression. Leave to dry.

3. Position the cloud mask in place and sponge-roll plain turquoise paint over it, working from the mask onto the box. Use the brush to drag lines so the paint doesn't look too even. Leave to dry.

4. Use the sponge to dab turquoise and blue **through** the spring stencil positioned **over** the cloud and mat print. Let the box dry well and apply two coats of varnish.

IT'S A MIRACLE HOW MANY KINDS OF LIGHT THERE ARE IN THE WORLD, HOW MANY SKIES: THE PALE BRIGHTNESS OF SPRING . . .

LAUREN OLIVER

MONOTYPE PRINTS

A monotype is essentially a printed, spontaneous painting and is not presented as an edition. As such, is it the most painterly form of printmaking and is different from a monoprint (see page 65), although both types can be hand-printed or run through a press.

Monotypes can be:
- **Additive**: where inks or mediums are painted or drawn onto a plate for printing.

- **Simple once-off**: a single layered print, either additive or subtractive.

- **Subtractive**: when an inked plate is drawn into or wiped to remove medium before printing, as part of the design.

- **Complex overprints**: multiple layers on the same print, registered and reprinted to build them up.

Glass or rigid plastics (Perspex or clear acetate sheets/trans-parencies) are most commonly used as printing plates for mono-types. However, prints can be made directly off kitchen counters, school desk tops, baking paper, fun foam, plastic book covers or bags. As long as you clean the ink off the surface as soon as you are done.

DONKEY PRINCE

It's as easy as "hee-haw" to print this drawn monotype. It's just tracing, while transferring ink onto the back of the tracing. I think my original looks a bit like Alan Rickman—I trust he would not be offended as I admire his acting as well as his looks!

YOU NEED

Drawing—your own or a copy
(acknowledge your source)

Sheet of glass, Perspex or acetate

Scrap paper (for practice) and quality paper (Remember that copy paper is acid free so can be used as well)

Printing ink—black lino or dark colors

Brayer

Pencil, ballpoint pen, stylus or ball tool

1. Roll a **thin**, even layer of ink onto glass, Perspex or acetate—thick ink will smudge so practice on scrap paper.

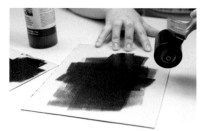

2. Place the drawing face-up onto the inked surface. Paper won't shift on sticky ink if you work gently and carefully.

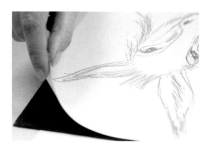

Note: Print directly **on the back** of your drawing or copy paper for the best effect, or use a blank sheet in between to print on as you trace your drawing from the top. To keep your original clean of ink, use copies instead. (Originals can be resized too.)

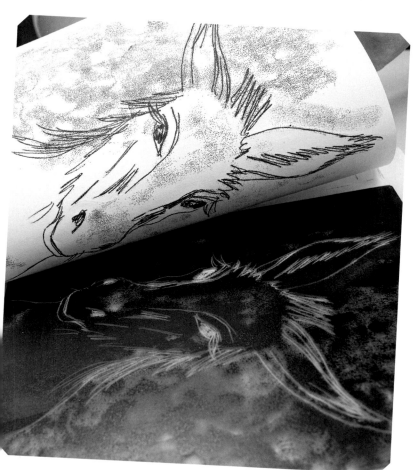

SOMEDAY MY PRINTS
WILL COME

ANONYMOUS

3. Trace your drawing with the pencil, pen, stylus or ball tool. Ensure that your hands don't press around the drawing too much, as this will also transfer marks.

4. Gently peel one corner of the paper off the glass and check the ink lines on the back. If they look strong and clear, decide if you want to add more inky smudges to add to the tonal value of your print. If so, gently use your fingers to press a little ink onto certain areas of the print, and keep peeling the paper back to check the transferring of the ink.

5. Lift the paper when you are happy with your monotype.

You can repeat this process many times with the same drawing and each print will be subtly different, which is why it is called a monotype (once-off) print. Although this method is subtractive, you can try an additive process with the same plate by drawing the design onto the plate with Inktense dye blocks or pencils, and then burnish damp paper or fabric onto it to pull a print.

With fabric printing monotypes, there are three options to choose from, using one line drawing. See "Impressing" in our other books, *Fabulous Fabric Paint* and *Simply Fabulous Fabric* for further ideas. This is the same basic process as the donkey print but with two fabric layers instead of a plate and paper.

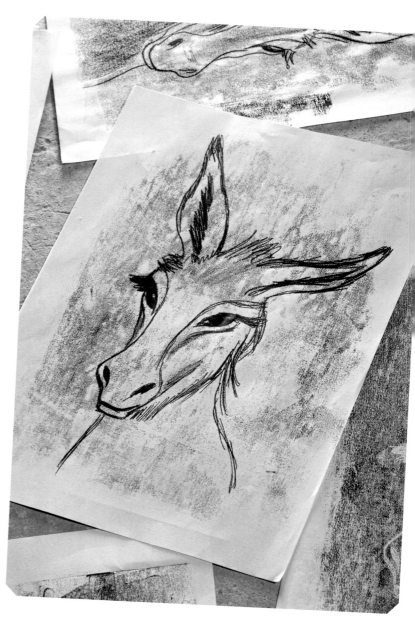

MORNING GLORY MAGIC

These beauties flower outside my kitchen window and their lovely shaped leaves are perfect for printing too.

YOU NEED

- Drawing of a morning glory—pencil-traced onto a piece of white or cream cotton fabric
- Sticky board—hardboard coated with stencil glue (see glossary)
- Sponge
- Fabric paint
- Second piece of plain cotton fabric of the same size
- Dead ballpoint pen (stylus)

1. Smooth the **plain** piece of fabric flat on the sticky board and color it evenly and randomly with fabric paint and the sponge, working it in well.

2. Lay the other piece of fabric—with the pencil tracing **face-up**—on top of the still-damp, painted fabric and carefully retrace the lines with the dead ballpoint pen (stylus). The fabric paint will show through as you trace, changing the fine pencil lines to colored lines.

> PRINTMAKING IS FUN BECAUSE IT TAKES A PERFECTLY SIMPLE PROCESS LIKE DRAWING AND MAKES IT AS COMPLICATED AND ERROR PRONE AS POSSIBLE
>
> GEORGE BODMER

3. Lift off the top cloth, revealing a "negative" image on the painted cloth and a reverse (more smudgy-looking print) on the back of the top cloth. You now have the option of three prints to use or color—one on the traced top **or** one on the back of the tracing, **or** the one on the painted cloth. Use watered-down transparent paints for watercolor effects, opaque paints for light-on-dark effects, or simply leave the print plain.

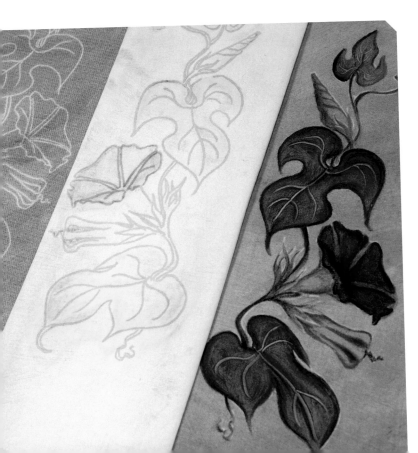

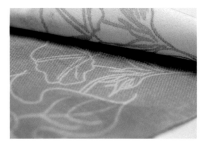

FLOWERS OR FIGS?

Free painting monotypes can be printed once, or repeated in layers to form rich dense prints in whatever slow–drying medium you use. Free painting implies no copying, but you can place a reference image or picture underneath a clear plate. Cheap watercolors bead up on slick plate surfaces and print fuzzily so instead use thinned oils or good quality tube watercolors.

YOU NEED

Flat, non–absorbent surface—a cleaned x–ray, transparency or sheet of glass or Perspex (roughen with sandpaper for a bit more tooth)

Tube watercolors and water **or**

Oils and turpentine for dilution

Medium soft brushes for both paint types (nylon for softness and control)

Good quality watercolor paper—at least 140g

Metal spoon and brayer

Spray bottle of water

Gel crayons and water soluble pencils for finer details on watercolor prints **or**

Pastels on oil prints

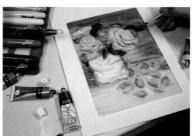

1. If you are copying a painting or using a photograph as a reference, place your original underneath the printing plate so you can see it easily. Paint colors onto the clear plate following your chosen design, using the soft brushes. Use water or turpentine to dilute the paint but not too much.

2. If using watercolors, allow the paint to dry completely on the printing plate while you soak printing paper in water (for at least five minutes). Blot the paper on a towel until the surface looks matte—not wet and shiny.

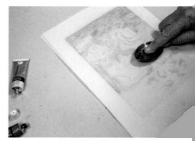

3. Place the blotted paper into position on the painted surface and allow it to settle before gently pressing down with your hands and then rubbing with the spoon. If you are worried the wet paper may tear, cover it with a sheet of wax paper and rub on that—don't shift the paper or the print will smudge.

PRINTMAKING IS ALL ABOUT DEFERRED GRATIFICATION

ANONYMOUS

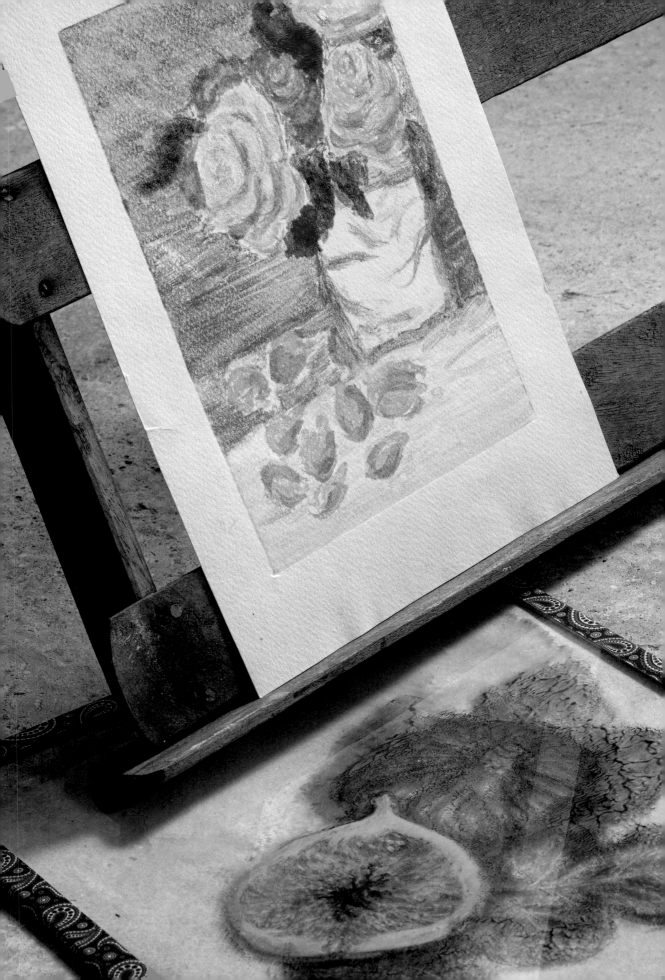

4. Use one hand to keep the print flat and lift a corner to check transference. If it is too light, mist the back of the paper with the spray bottle and leave the water to soak in before rubbing again.

5. Oil paints are easily printed in the same way, but without drying or using solvents on the paper as they are sticky enough to transfer easily.

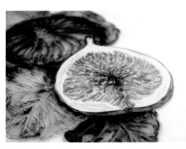

These prints have a translucent, painterly quality about them and although you can repeat the same copy, subtle differences in each will create a fascinating array of monotypes. Try layering colors for backgrounds before painting detail on top, to build complex, rich images. Add further details using gel crayons and water–soluble pencils on the watercolor monotype, or pastels on the oil print.

Below: Encaustic beeswax colors mixed with metallic or mica flakes and damar resin impart a wonderful shimmering translucence to an ordinary sheet of copy paper.

WAX ELOQUENT

I use my own mix of encaustic colors, beeswax, crayons, pastels and oil paint sticks to create monotype prints on paper. Most encaustic mediums contain wax, mixed with damar resin, which gives a hard-lasting finish and color-brilliance to wax painting. Carnauba wax can be substituted for resin, but is expensive. If you are experimenting, and not fussy about lightfastness or archival quality, play with beeswax, pigments and paint sticks.

Crayon colors fade but oil paints fuse color to wax easily. Pastels and crayons contain clay and pigments to increase opacity and color density, which can affect your wax painting. Using beeswax as a medium is not a purist approach but does make the finished work flexible and resistant to wax cracking or flaking off the surface of your artwork. Once you are hooked, order good quality encaustic colors and other supplies online.

YOU NEED

Hot tray (and a heat gun—optional)

Beeswax and something to color it—crayons, oil pastels, oil paints or paint sticks (and encaustic blocks if you have them)

Paper towels, cotton swabs, rubber shapers or eraser-tipped pencils

Paper—thin and porous is good for wax monotype

Spatula or brayer

1. Switch on the hot tray and start with medium heat. You may have to adjust the temperature, depending on your appliance.

2. Slowly draw beeswax over the heated surface and add colors. Draw with the tips or sides of crayons, pastels and sticks until you like what you see. Bear in mind that your print will be more of an abstract, imperfect, blurry, reverse image of this.

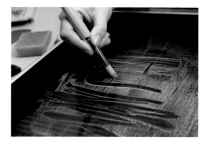

4. Gently lay paper onto the melted wax and allow it to settle in place. The wax will be drawn into the paper and the back of the paper facing you will become transparent, allowing you to see the transference of wax. Aid this by patting gently with the spatula or rolling lightly with the brayer.

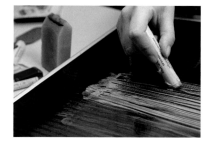

3. Wipe parts of your "painting" away with paper towel, cotton swabs, rubber shapers or eraser tipped pencils. Add texture by pressing in elements and removing them. (You could also try adding stencils before placing paper over the waxed area.)

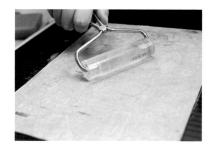

PRINTMAKING, LIKE SEX, IS NOT SOLELY ABOUT REPRODUCTION

ANONYMOUS

5. When the painting has been absorbed into the paper, let the tray cool a little before lifting the paper carefully to reveal the print. If the wax is too hot, it will slide and drip—which can be interesting, or disappointing!

Optional: Reheat and rework the image face-up on the tray. Draw into the print directly with more wax and oil mediums—you will have more control to add finer details. Metallic paint sticks and metal leaf add rich shiny glints to the translucence of the wax. Keep drawing and printing layers; the higher the beeswax-to-color ratio, the more translucent the layered effects will be.

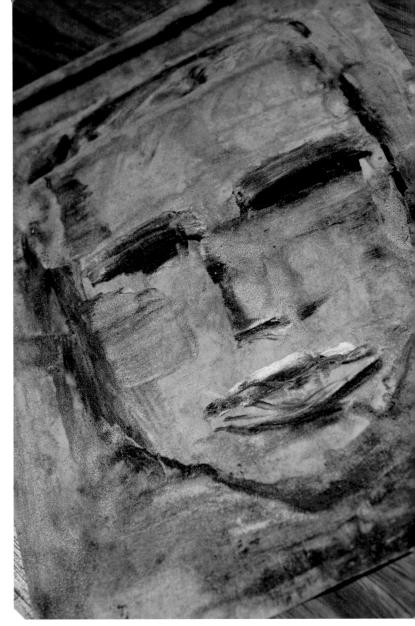

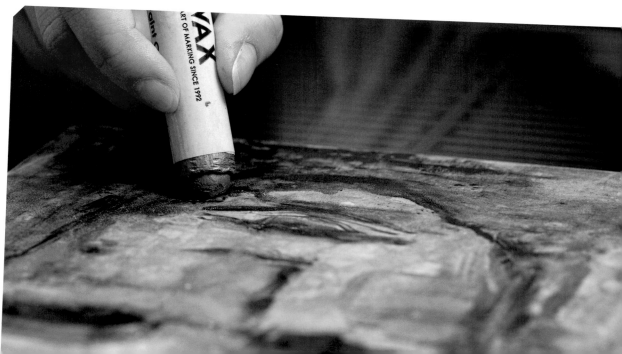

ids—but by using blocks,
asily repeated and are
ly unique in its own right as a
nteresting and spontaneous,
ons. However, collagraph
e process becomes addictive
...ent with as many ways, colors and textures as possible to produce fascinatingly unique variations of designs.

GEL PRINTS

One of the best monoprinting printing plates, or pads (they are flexible), is made with gelatin and water. Gel printing became popular in the 1930s when ordinary food-grade gelatin was used to make printing pads; this technique is still used today. Although easy to make, they need refrigeration and disintegrate with constant printing pressure.

A better option for creating more permanent—or at least reusable—pads are hectographs (so named because they can create "100" prints). These were developed in late-19th-century Russia and used extensively in the early 20th century. The gelatin surface of the hectograph pad absorbs drawn or typed images in hectograph ink (see Recipes), generating many identical copies. Hectographs were a primitive precursor to photocopy technology. The story goes that during World War II, prisoners in Germany's Colditz Castle made copies of their escape plans using homemade hectographs.

Many school teachers from the 1960s and '70s will recall jelly printing, as they called it. More recently, crafters and artists discovered gelatin plates as tools to create colored, layered and textured prints on fabric or paper, using a plethora of inks, stamps, masks, stencils and other printing tools and accessories, such as found objects, texture plates and die cuts.

See Recipes to make your own gela pads, as I call them. Commercial "Gelli Printing Plates" (a branded product of Gelli Arts) are synthetic gel substitutes, made from silicone and mineral oils. These can be ordered online (www.gelliarts.com). There are many support blogs and YouTube videos created to share ideas, techniques and results using Gelli Plates. They work excellently for printing on paper and I treasure mine and use it often, but prefer my gela pad for printing fabric; the moister, spongier surface prints inks more clearly onto fibers. I also have the much more affordable option of making any shape or size pad I want.

Another advantage is that if it gets damaged or discolored with constant use, it can be melted down in the microwave, filtered to get rid of impurities and reset into the same, or different, shape. Covered with acetate, it stores indefinitely in a cool, dry place and is always ready to use.

The only disadvantage—compared to the commercial version—is that it's not a good idea to wash it, as it will dissolve in water, whereas the silicone version does not. So instead clean gela pads with wet wipes or hand sanitizer spray. See Recipes for how to make refills, homemade wet wipes (which work brilliantly) and a wax gel pad for using with oil-based paints. Another alternative to the Gelli Plate is a sheet of fun foam. This holds paint and can be used similarly for many effects, including stenciling, very successfully—which is an especially affordable option, making it suitable for children.

Gelli Plates and gela pads can be used for so many monoprinting techniques that I could fill several more books!

Here are some tips:
- Use soft rollers (sponge or rubber brayers), sponges, cotton swabs, raised stamp pads and a variety of brushes as color or medium applicators.
- "Open" acrylic paints (slow drying), acrylics with retarders, or fabric paints (with extender as a base) are suitable for inking the gel pad. Other paints and inks dry too fast or bead up on the surface. If you want to use oil paints thinned with turpentine, work on a wax gel pad (see Recipes). I use one for printing on soap and candles.
- A wide variety of papers and cloth—without too much textural variation—are suitable for printing on. Glossy papers will stick to the surface, and delicate papers will need to be supported (see Chine collé) with glue on card or ironed to freezer paper. Deli paper, copy paper and cardstock are essentials. Try overprinting sheet music, wrapping paper, brown paper, scrapbooking paper, watercolor paper, baby wipes, interfacing and tearaway (see Glossary).
- Use clear mediums and slow-drying waterbased glues, rolled onto the pad, to seal papers and as resists.
- Cover any dried acrylics on the print pad with heavy-bodied acrylic paints to pull intense ghost prints.
- Adapt any of the stamps, stencils, texture plates and designs featured in both this and our other books—especially *Paint on Paper* and *Artful Ways with Mixed Media*.

It's a most addictive obsession and the only therapy is to keep on printing, muttering, "What else can I try?"

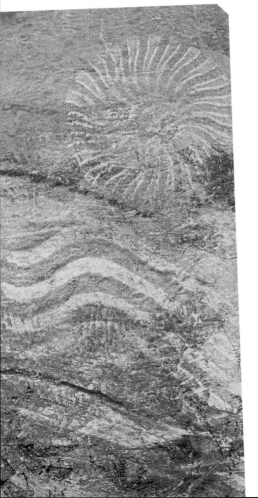

HECTOGRYPHON

Use fabric dye instead of hectograph ink in a reverse process—similar to gel printing—using a disposable gelatin pad. There are occasions for using a disposable pad instead of the gela pad or Gelli Plate—particularly in this case, when dyes will stain the gelatin. I used this print to repeat backgrounds for a fine-lined screen printing design.

YOU NEED

Fiber-reactive dyes dissolved in a little hot water (I used red and blue)

A sheet of smooth watercolor paper, or cardstock, and lots of plain copy paper

Sponge brush

Gela pad

Stencil or mask (I used a gryphon)

Glass and heavy book

"THAT'S THE REASON THEY'RE CALLED LESSONS," THE GRYPHON REMARKED: "BECAUSE THEY LESSEN FROM DAY TO DAY"
LEWIS CARROLL

1. Sponge dyes onto the smooth watercolor paper or card, and leave to dry.

2. Place the stencil onto the gela pad and cover with the dry, dyed paper or card, then cover with the glass and heavy weight. Leave for several hours for the gelatin surface to absorb the dyes through the stencil or mask.

3. Remove the paper to reveal the darker positive stenciled design against the lighter areas where the dye has transferred to the gelatin surface. Remove the stencil from the pad.

Negative prints can be pulled by laying plain paper on the dyed gelatin for a few minutes to reabsorb colors as for hectograph printing. When colors become faint, dispose of the dyed gelatin pad.

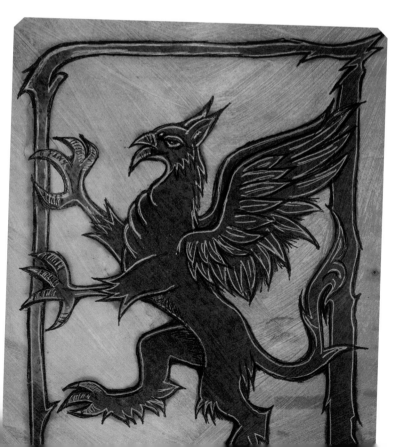

JELLY ON THE TABLECLOTH

This extra-long outdoor tablecloth needed a makeover, as the original paint was not properly heat-set and washed off patchily. The color was drab so I redyed the cloth before printing. As the design was faintly visible, it was easy to use it as a registration guide for overprinting. I created large, homemade geometric "stamps" to cover the original pattern.

YOU NEED

Perspex

Geometric designs

Plasticine

Gela pad ingredients (see Recipes)

Scalpel

Sponge roller

Fabric paint

Above: The tablecloth before the makeover

1. Place Perspex pieces over the geometric designs. Make shaped "stamp molds" by placing plasticine strips on the Perspex following the design lines. Build "walls" of plasticine to contain the stamps, then pour gela pad mix into the molds and let them set.

2. Remove the plasticine, leaving the gel designs attached to the Perspex—like oversized cling stamps on clear acrylic blocks. They may be further modified with a scalpel.

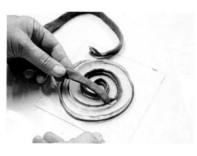

3. Roll the Perspex gel stamps with paint and press, **gel–side down**, on to the cloth to print. Reroll and print until done.

ONE CAN'T NAIL JELLY TO A TREE

ANONYMOUS

Right: After overdyeing the cloth the "wrong" side looked so pretty I decided to decorate it with a simple stenciled "net" design—so I can use both sides now!

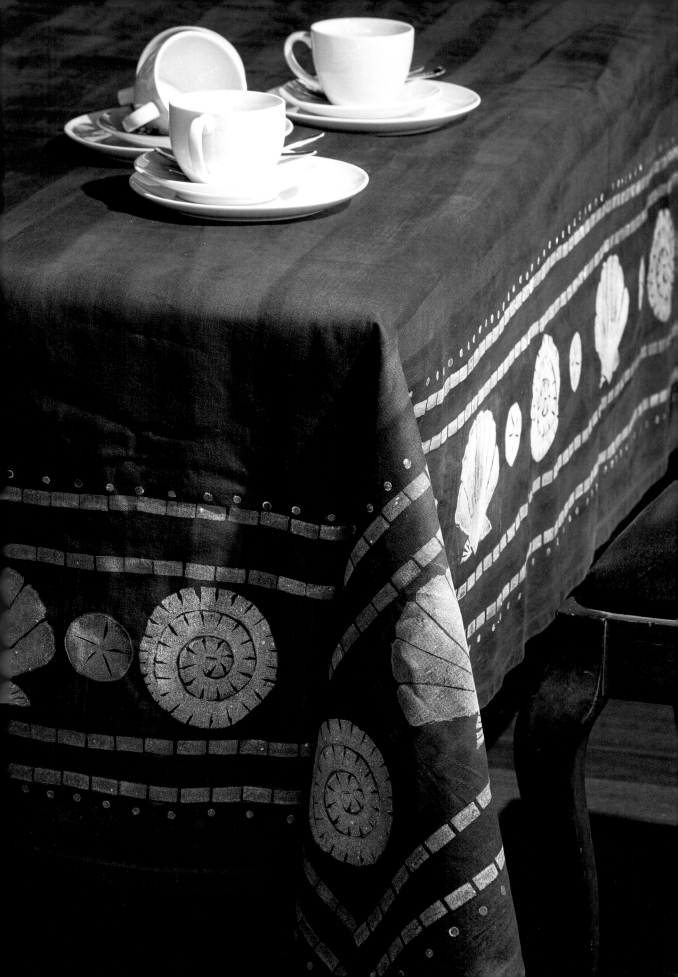

BAGS OF BUNTING

The beauty of a homemade gela pad is that you can cut it to shape for a geometric print, and then remelt and mold it back into a rectangular pad when you are done. Commercial Gelli Plates can be cut with scissors, but are very expensive to destroy as they cannot be remolded at home. I printed paper party bags using plastic doilies as masks. These are a more affordable and user-friendly option than paper doilies. When the bags were done, it was simple to cut the pad to the exact shape for printing matching bunting. The other advantage of the homemade gela pad over the commercial version is that you can print glossy paper without it sticking to the pad and tearing—perfect for the very shiny paper bags and bunting that I bought.

YOU NEED

Readymade bunting (paper or cloth)

Gela pad

Ruler

Craft knife

Fabric paints (I used denim and cerise)

Sponge roller

Plastic doilies

1. Lay a bunting triangle onto the surface of the gela pad. Use a ruler as a guide to cut the gela pad to fit the bunting shape.

2. Roll one color onto the triangle pad, and then partially cover with one or two doilies. Pull a print on one of the bunting flags.

3. With doilies in position, roll a second color over the doilies (and pad) and pull another print on the next flag. Remove the doilies and pull a ghost print on the next pad and so on. Keep going until your string of bunting is done—print the reverse sides too if you like!

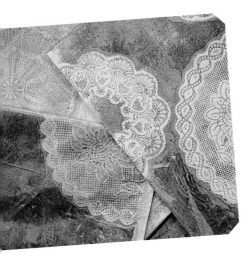

Above: Printed packets

IF YOU FEEL GOOD WITH WHAT YOU'RE DOING, LET YOUR FREAK FLAG FLY

SARAH JESSICA PARKER

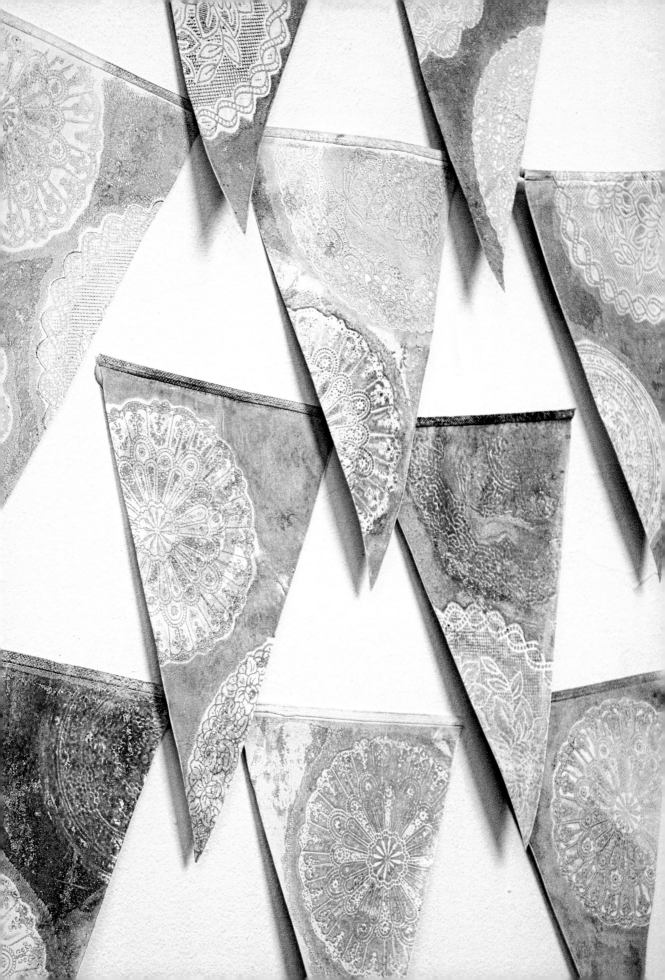

JUST HANGING AROUND

This is a simple exercise in which to create and work with masks and ghost prints.

YOU NEED

Gela pad

Soft brayer

Blue open acrylic paint

Yellow open acrylic paint

Notched scraping tool or comb

Sewing thread

Pictures of clothing cut from magazines as masks—laminate with contact paper to strengthen before cutting

Copy paper

Tweezers, pin or palette knife

1. Roll blue completely across the pad for the sky. Scrape some short vertical lines along the bottom before rolling yellow (which will turn green with yellow lines) across the lower quarter of the pad to represent grass.

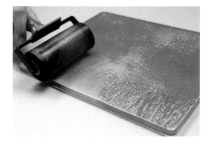

2. Lay two strips of cut paper on the left and right for washline poles, and drape the thread across them to create the washing line. Position the cut clothing masks along the line.

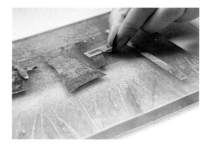

3. Cover the pad with a sheet of paper, and press lightly all over with your hands before pulling a print. This print features negative white silhouettes against a blue sky with green and yellow grass.

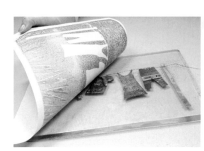

4. Remove the clothing masks, washline and poles with the tweezers or pin. Cover with paper and pull a ghost print. This will pick up any remaining paint on the pad as well as the paint left where the masks were. It will be a more interesting, but possibly faded, positive, depending on how much ink was left to pick up.

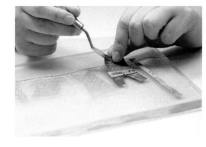

Variation: In step 3, do not remove the printing paper, but lift a part of it so that you can remove all the masks before relaying the paper—thereby allowing the ghosts to print into the negative spaces.

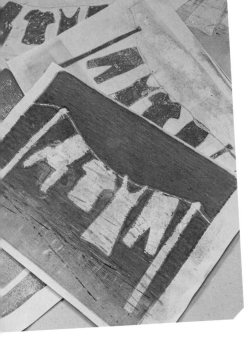

PRINT THAT, PEOPLE.
SEE WHERE THAT GOES

CHARLIE SHEEN

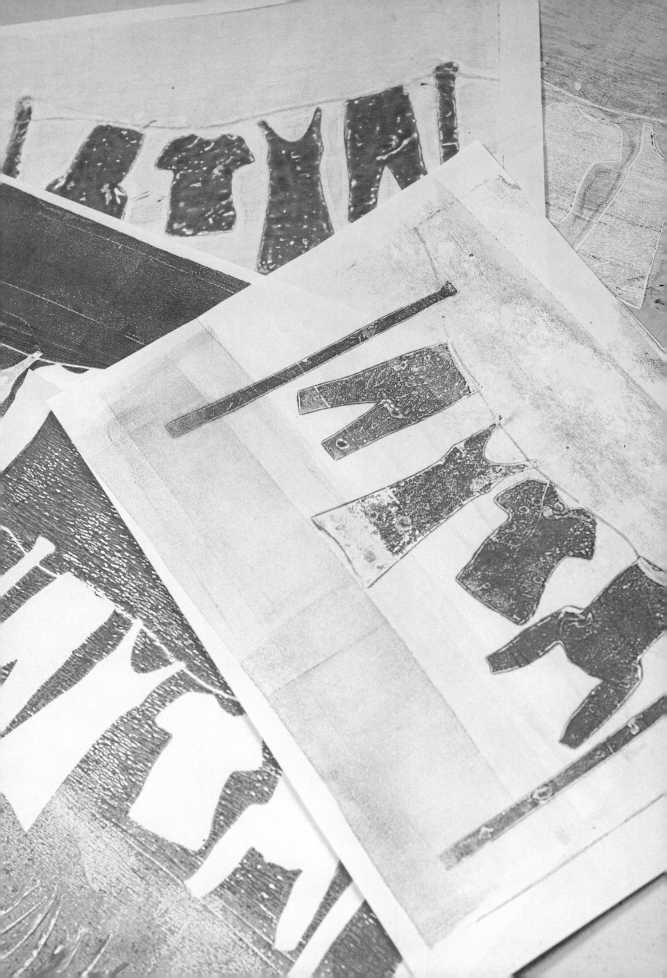

AGAPANTHUS "FLOWER OF LOVE"

Layer a single cut positive (stencil) and negative (mask) for multiple print variations. Use this method to print any silhouette stencils in your collection in countless combinations.

YOU NEED

Blue, magenta and yellow open acrylics

Acrylic thinner or medium

Gela pad

Sponge

Agapanthus stencil and mask
(positive and negative)

Brayer

Bubble-wrap, combs and cling-wrap

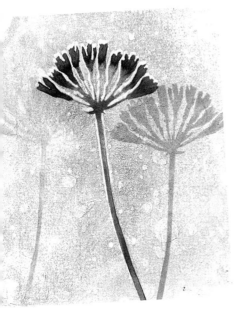

AGAPANTHUS: FROM SOUTH OF THE NILE, THESE LILIES ARE QUITE VERSATILE. THEIR SUMMERY BLOOMS, BROUGHT INSIDE BRIGHTEN ROOMS, BUT IN WINTER, THEY'RE GONE FOR A WHILE

JANE AUERBACH

1. Blob a few dots of two of the colors and a little medium on the pad and sponge the colors all over, blending them artistically.

2. Position the stencil negative, cover it with paper and pull a print. Remove the negative and pull a second, positive ghost print.

3. Roll another color combination (with one color common to the first two prints) over the pad and stamp sections with bubble wrap,

then comb patterns and lastly, press scrunched cling-wrap to remove color in parts. Place the stencil positive over **one section** of the paint-textured pad, and use the second print again to pull another positive. This one will be textured and strongly colored. Try to place it so it slightly overlaps the first flower.

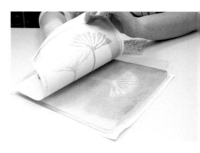

4. Repeat these positive and negative stencils with different textured and colored paint applications, until you have created some beautiful prints.

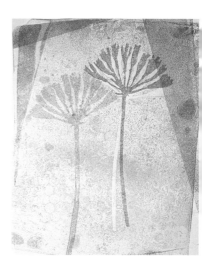

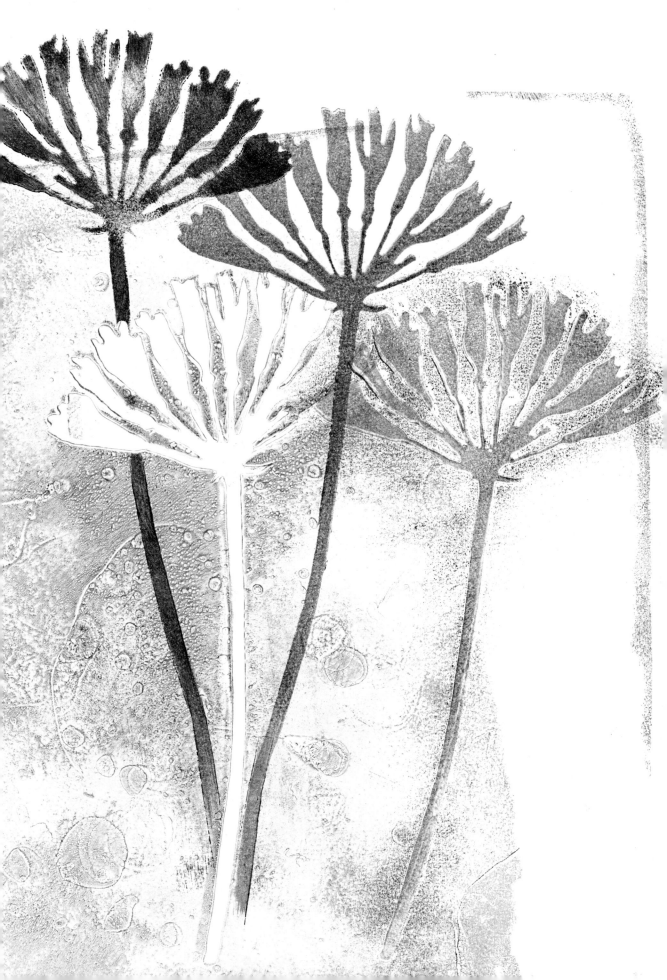

PROTEA "POWER OF LOVE"

Sarah and Waldo Boshoff wanted to make their own wedding invitations and were delighted with the idea of gel printing stenciled protea images onto cards. Each guest would receive a unique artwork, and at the same time be able to sign a printed cloth square which would go toward making a quilt for the newlyweds to cherish. We formed a production line team and printed more than 280 paper and fabric squares in one evening! This is a group project for six people.

YOU NEED

Brayers, sponge rollers and brushes

Harmonious range of fabric paint colors—blue, green, gray, pink, red and extender

Paper and fabric—cut into as many 6" x 6" squares as you need, plus more for practice

6 gela pads—also cut into 6" x 6" squares

Polystyrene vegetable trays and plastic teaspoons for mixing paint

Bubble-wrap, texture plates, mats, combs, stamps and plastic needlepoint canvas

6 protea positive stencils (the designs have too many small windows to be able to use the negative pieces)

1. Create background prints on cloth and paper by rolling, sponging and printing various color and texture combinations—with all the tools—on **a third of the cloth** and paper pieces. (So if you started with 90, a third is 30.)

2. Hang each to dry as you print them. Continue applying color and textures to the pad as for step 1, but cover each inked surface with a stencil, and pull a textured positive onto a third of the **remaining blank papers** or fabric squares (the remainder is 60, a third of which is 20, with 40 remaining blank). Hang to dry.

3. Remove the stencils from the pads and print the ghosts onto **half** of the blanks. Hang to dry.

4. Reapply a mix of darker color combinations on the pads, cover with stencils and print protea positives over the background prints from step 1.

5. Leave the stencils in position on the pad and roll over the whole stencil with yet another layer of color, texturizing this too before pulling a print. The subtle outlines or haloes created look photocopied.

6. Lift the stencils and print ghosts from these on the remaining blanks. Working on both sides of the stencil offers mind-blowing possibilities, so keep going—onto T-shirts, fabric, scarves . . .

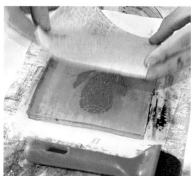

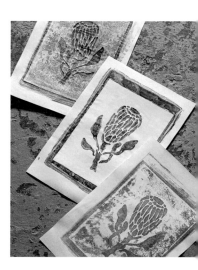

MORE ART, FASTER!
ANONYMOUS

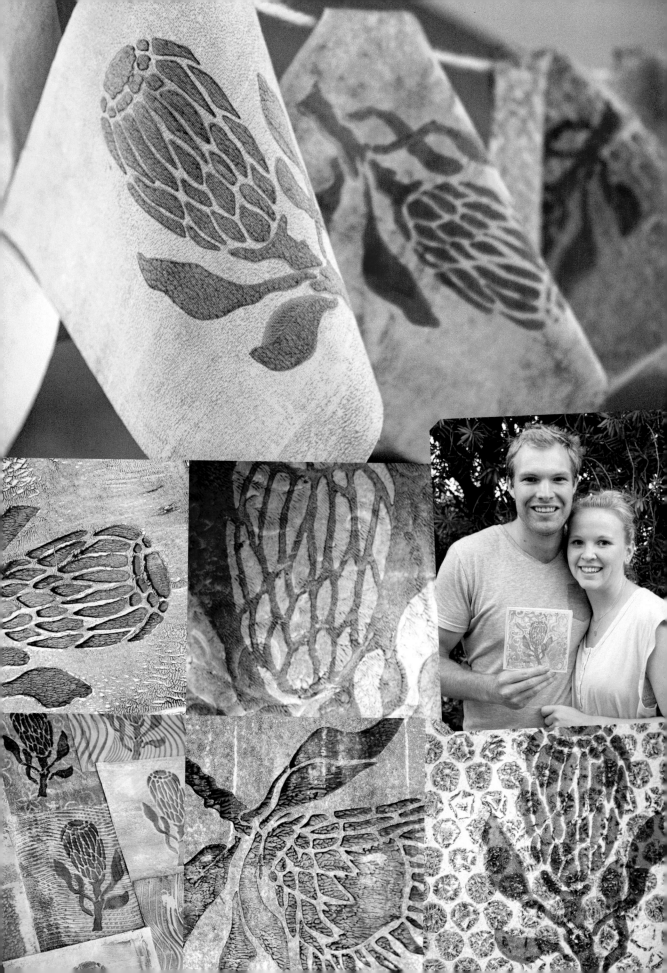

DEEP IN DUSTY MILLER

My studio garden is being conquered by a beautiful alien. I prefer indigenous plants but dusty millers are so lovely and useful—complementing and softening any bed or edge with soft gray feathery fronds—that I can't dig them up. They make shapely masks for sun printing and anyone who comes to learn gel printing with me enjoys experimenting with layering these (and taking slips home to plant).

YOU NEED

Two open acrylic colors—light and dark

Sponge roller and soft brayer

8½" x 11" gela pad

Fern, daisy, or similar leaves

8½" x 11" scrap paper

Soft, finely textured paper (like handmade Japanese washi paper) or tearaway cut or torn to 8½" x 11" size

1. Roll the light color with the brayer evenly and vertically over half the pad. Lay two leaves (of different lengths) **vein-side down**, one on the paint and one directly on the pad. Cover with scrap paper and rub well, paying attention to the leaf edges under the painted side, and pull a print. Leave the leaves in position on the pad.

3. Mix the light color with a little o the dark to tone it down. Sponge-roll this onto the pad and put one more leaf **face-down** in between— or overlapping—the others. Make another scrap print (you can reprint using the scrap from the first prints).

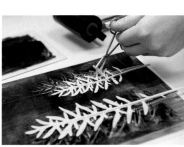

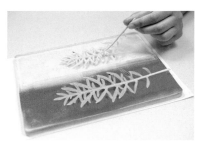

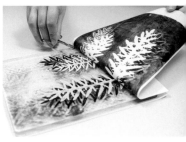

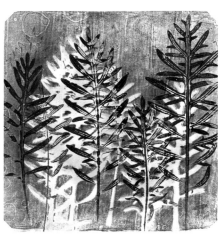

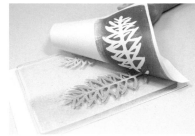

2. Sponge-roll the dark color over both leaves. Place two new leaves onto the pad, slightly overlapping the first two. Re-cover with scrap, rub and pull another print.

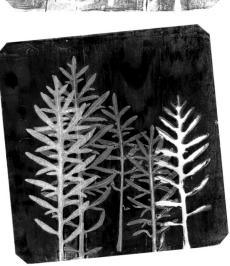

PULVIS ET UMBRA SUMUS
(WE ARE BUT DUST
AND SHADOW)

HORACE

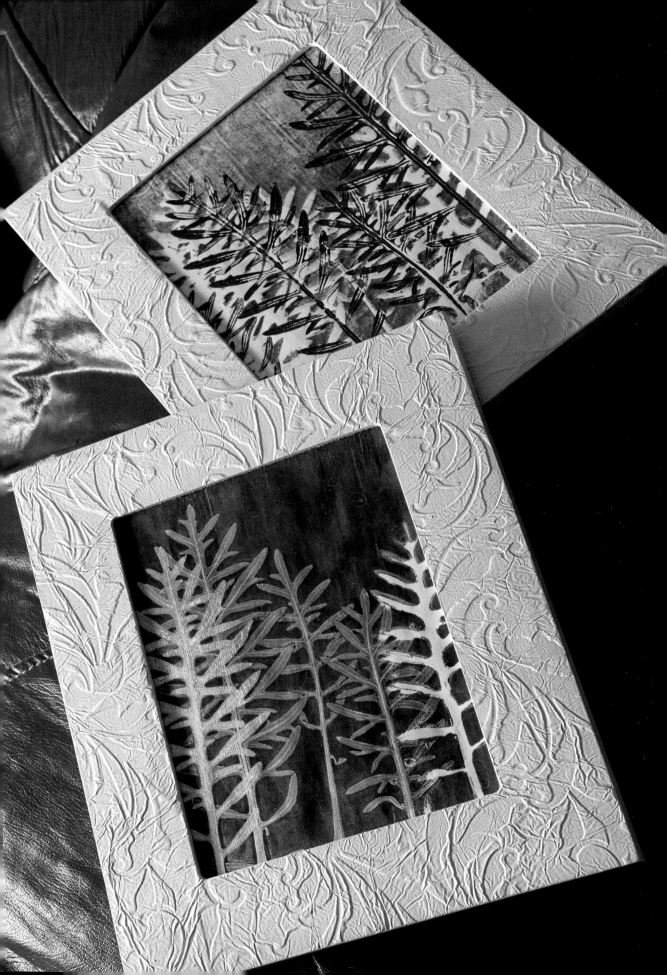

4. Mix the light and dark to a mid-tone and sponge over all the leaves, rolling vertically so as not to disturb them.

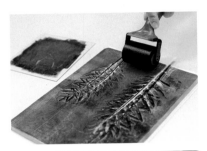

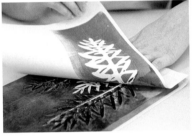

5. Remove all the leaves and place them, **paint-side up**, to one side.

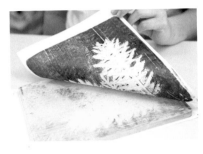

6. Cover the pad with the good quality paper and pull a print showing all the leaves in graded tones from light to dark. Pull a ghost print if possible.

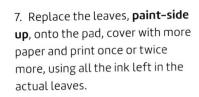

7. Replace the leaves, **paint-side up**, onto the pad, cover with more paper and print once or twice more, using all the ink left in the actual leaves.

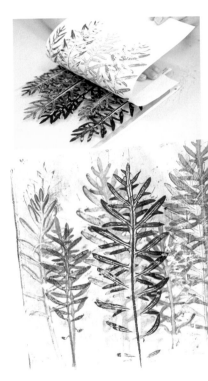

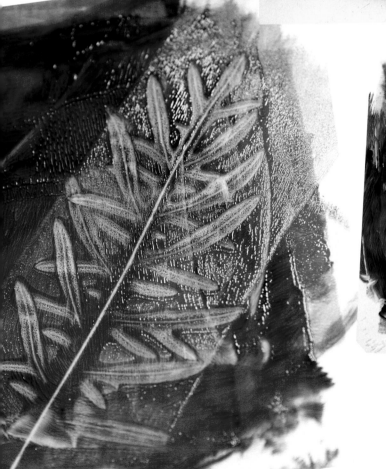

While rolling leaves with ink, leaf impressions form in on the roller itself—these can be rolled off onto blank paper for further interesting prints.

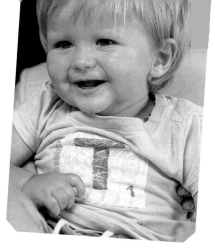

T-SHIRT

I made this to celebrate a special little boy's first birthday. The T stands for textured T-shirt and his first name, Tristan, as well as the Scrabble score of 1. I could have used freezer paper stencils ironed directly onto the fabric, but used see-through contact paper instead as it enabled exact placement of the layers building the image. Stencils adhered temporarily prevent color from bleeding under the cut edges. This is an "off-set," rather than a direct method of stencil printing, as the textured layers are first created on the gela pad and then lifted off through stencil windows to build an image. The card and envelope were printed at the same time using the gela pad, and gift wrapped in potato-printed stamped stars.

YOU NEED

Clear contact paper

Craft knife and cutting mat

T-shirt (iron a piece of freezer paper onto the inside front to prevent paint bleeding through to the back of the shirt—or slip a bit of paper or plastic inside)

Design and marker

Gela pad

Brayer

Transparent fabric paint (I used orange and turquoise)

Textures—stamp, comb scraper, scrubber, bubble wrap, tile grid, silicone icing mat

Opaque fabric paint (I used white)

Scrap paper

Card and envelope

1. Cut a square (mask) from the center of a piece of contact (window) large enough to cover most of the front of the shirt. Peel off the backing paper and place the window piece in position. Peel the backing paper from the mask and set aside to use later. Position the sticky mask over the open square of fabric, slightly up and to one side, leaving an L-shaped opening for a colored "shadow" to be printed.

2. Roll the shadow color (orange) onto the gela pad and texture it with the comb scraper. Place the L-shaped open area of the T shirt **directly onto** the textured paint and pull a print. Rub carefully so that all the paint transfers through the open area. Make ghost prints onto the card and scrap paper to use up the paint.

I MADE A T-SHIRT THAT SAYS "TODAY'S MY BIRTHDAY" ON IT

JAROD KINTZ

3. Peel off both the mask and window carefully. Dry the print with a hairdryer before repositioning the window so that it completely covers and lines up exactly with the inside edge of the texture-printed L on the shirt.

4. Roll a rough square of opaque white onto the gela pad and texture with a stamp, grid, etc.

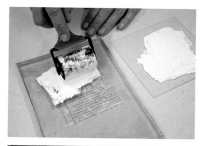

5. Press the open square window of the T-shirt onto the pad to transfer the print. Peel off the window stencil carefully. Again, make ghost prints onto the card and scrap paper. Dry the print thoroughly.

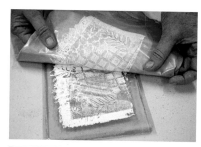

6. Draw the letter or design onto the backing paper square with the marker and cut the design out using the knife and mat. Roll turquoise paint onto the pad and texture it with the icing mat. Cover with the design stencil **face down** (or it will print backward). Cut a slightly smaller square in the scrap paper and cover the design stencil with this so that the design can be printed cleanly on the shirt.

7. Pull the print.

Again, make ghost prints onto the card and scrap. Dry and heat set the shirt. You now have a complete matching gift, card and gift wrap in one project.

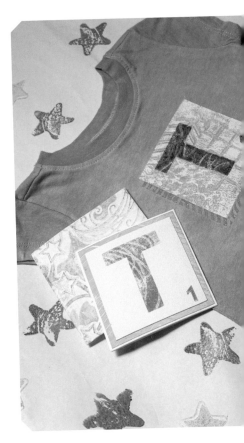

You will by now have a good idea of the creative energy generated by these addictive activities, not to mention the pile of prints accumulating. What to do with all of these? First sort them into three piles:

1. Prints that are finished: file them to use, display, sell or give away.

2. Prints that need more work: put them in your paper supply drawer for your next printing session so you can overprint, modify or embellish them.

3. Prints to scrap: this does not mean throwing away! Use these for collages, envelopes, book covers, scrapbooking or journaling—as many possibilities of which you can think. One that I particularly like uses all the scraps to produce printed art cloth, which I crafted in the next project.

ACCUMULATION ART CLOTH

This sturdy mixed-media style cloth can be constructed randomly with torn scrap, or deliberately with cut paper, in the style of patchwork quilting. Here are two methods.

On muslin:

1. Lay the muslin on freezer paper, or plastic, and paint with glue.

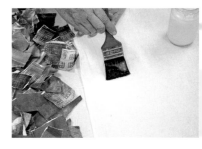

2. Apply torn or cut pieces of gel-printed papers all over the muslin, using more diluted glue and the brush. Torn pieces may overlap slightly and you can layer cut pieces over each other as for traditional patchwork patterns. Paint a layer of glue over everything.

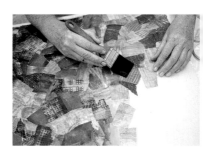

YOU NEED

Thinly woven fabric—such as muslin or spun-bond fusible interfacing

Freezer paper or black plastic bag

Glue mix—1 part wood glue mixed with 2 parts water, added to 1 part wallpaper glue mixed with 20 parts water

Paintbrush

Gel printed scrap papers—divide into copy paper and deli, baby wipe or baking paper

Iron, ironing board and Teflon sheet

Sewing machine (optional)

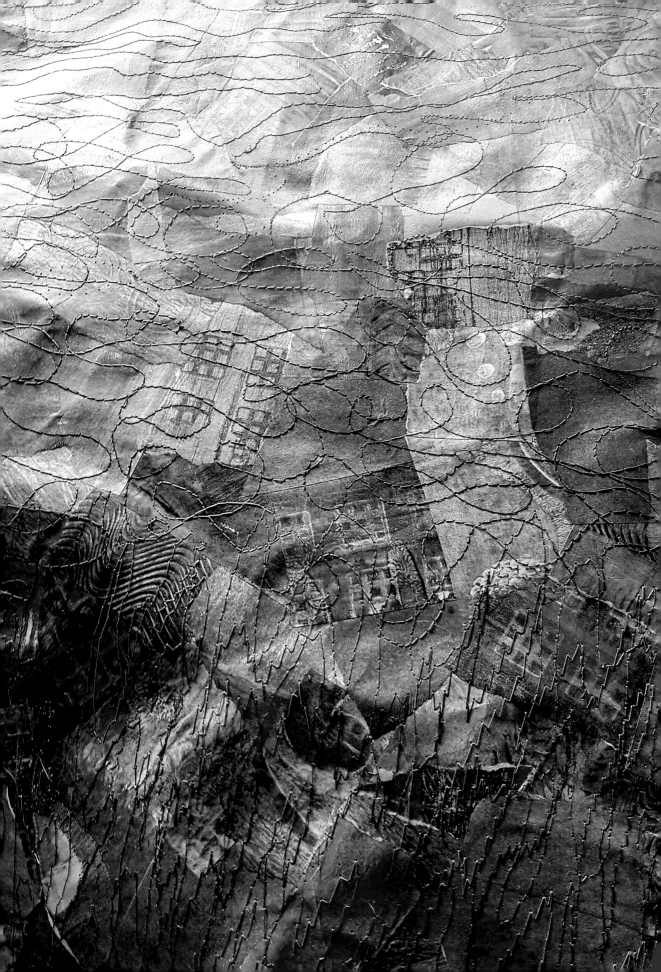

3. Dry flat, peel off the plastic and stitch the cloth all over with the sewing machine to strengthen it (optional).

On fusible interfacing:

1. Lay the interfacing, **fusible-side up**, on an ironing board.

2. Place torn or cut pieces of printed deli, baby wipe or baking paper, **face up**, all over the fusible surface, abutting each other without any gaps showing.

3. Cover with the Teflon sheet and iron with a hot, dry iron to fuse the thin papers to the interfacing. Stitch as for the muslin method or iron directly onto a canvas using applique paper (or see next project). This also makes a stiff, strong paper-cloth but it is not as durable as the glued cloth.

Art cloth may be further printed, painted or stenciled and used to make bags, covers or backgrounds for mixed media artworks. **Another option** is to glue torn papers directly to artists' stretched canvas instead.

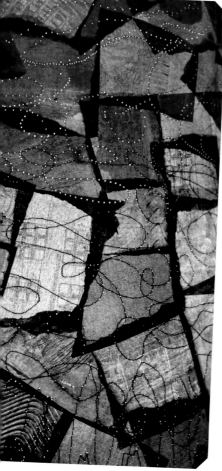

Left: Paper cloth shows up interesting stained-glass-like patterns and stitching lines when used for lightshades.

BROTHER SUN

After you have torn up chosen papers for art cloth, you will probably have a pile left that are too ugly, or too faint, to add useful color or design to art cloth. Don't throw these away—sort them into piles according to colors and use them for collage. Even the tiniest smudges of print can add the perfect touch in collage art. I used a simple method to collage an existing print that had faded and no longer suited the beautiful oak frame that my late friend Sarie had chosen for this commemorative poster of Saint Francis of Assisi. I tried to find the source to acknowledge this work but there is no reference to the artist anywhere.

One way to do "cheat collage" is to cut up an existing print as though you were doing a crazy jigsaw puzzle, and then glue suitable colored pieces of paper onto each piece before reassembling the whole. I chose to use appliqué paper instead as I want to keep the original print.

YOU NEED

Print or poster

Light box (or access to a backlit
window pane)

Tracing or black and white photocopy
of the print or poster

Black marker

Appliqué paper—double the size of the
print or poster

Discarded gel prints—in suitable colors
or textures to match design elements

Scissors (embroidery)

Pin

Iron and ironing board

Glue stick

Colored felt tip pens

1. Place the print or poster **face down** on the light box and trace the outlines of the design elements directly onto the back of the print with the black marker so that you have a simple line design. Cover with appliqué paper (rough, adhesive side down) and trace these lines onto the paper. Remove the print from the light box and set aside as a piecing reference.

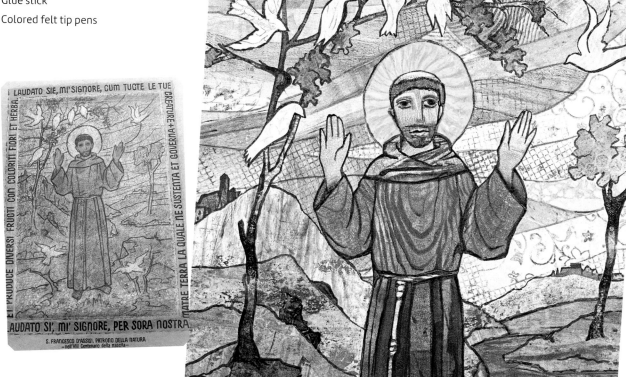

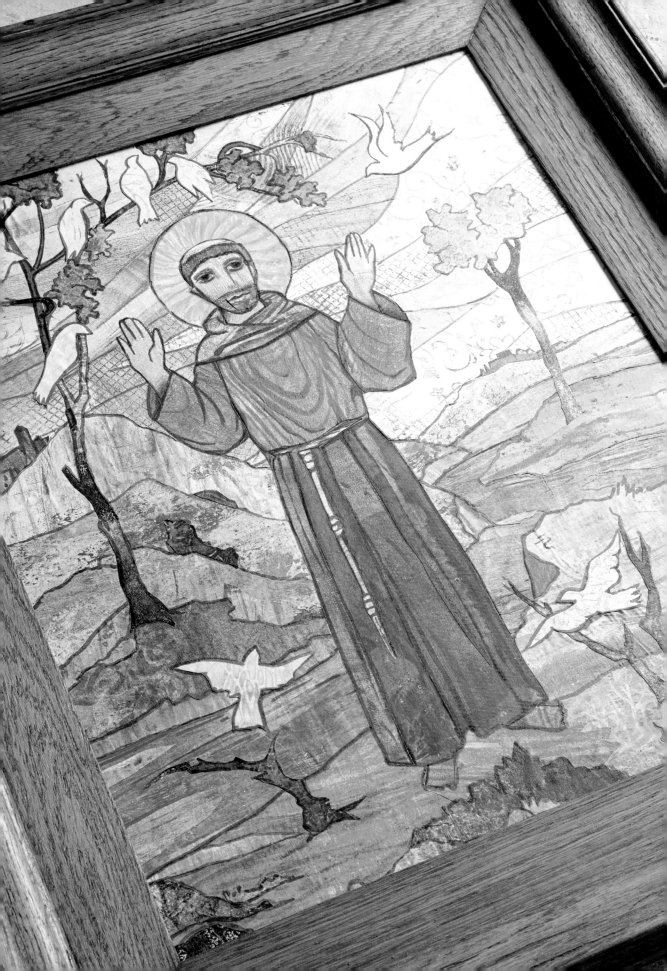

2. Cut each design element from the appliqué paper and iron it onto the back of a suitably colored and textured piece of gel print. These pieces can be cut exactly to fit as for a jigsaw, but I find it easier to cut background pieces, ignoring small elements (like the birds in this print). I retrace them separately onto extra pieces of appliqué paper so that they can be applied on top of the background pieces. This eliminates a lot of fussy cutting and fiddling. I am also then able to rough-cut the appliqué paper before ironing it down onto the back of the smaller elements, which makes final cutting much easier. I cut sweeping sections of sky pieces and then cut the trees and birds from extra paper to set them on top.

3. Remove the appliqué paper from the back of each ironed and cut piece using a pin. The adhesive will be stuck on the back of the gel print, which can then be ironed (adhesive side down) into position on the traced or photocopied print. Use the original as a reference guide for positioning—all the little bits can get confusing!

4. Keep cutting, ironing, trimming, fitting and sticking down pieces with the iron until the whole collage is pieced together. If some small pieces threaten to come loose, use a glue stick to adhere them temporarily before re-ironing. Use suitably colored felt tip pens to outline and define the design elements and bring the whole collage together so that it resembles stained glass.

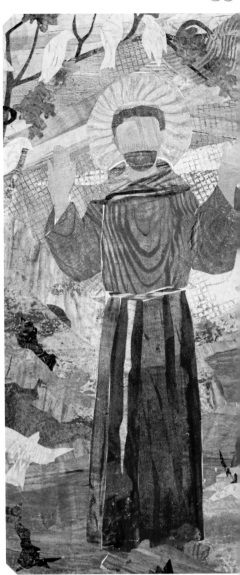

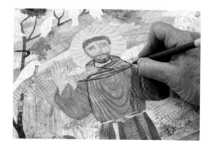

CALM DOWN AND WEAR BROWN

ANONYMOUS

CLAY PRINTS

Similar to gel printing, clay printing was developed by Mitch Lyons, a printmaker in the USA in the 1960s, who monoprinted using leather-hard clay beds and colored slip. He very kindly shares his process and work on the internet, knowing that all monoprinting is—by nature—unique, so copyright is not really an issue.

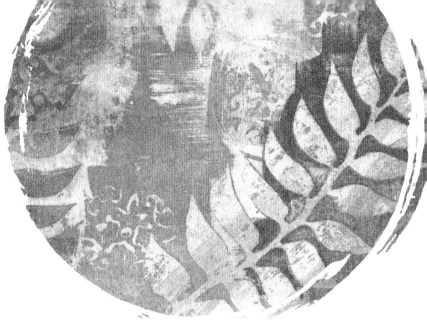

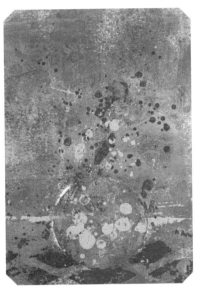

The effects created with clay printing are very special and have to be seen in reality, rather than experienced photographically. Each is one of a kind, with intense colors which seem to hover over the surface onto which they are printed. They definitely have more gravitas to them than easily tossed off gel prints. That does not mean that they are difficult to do—they just require a mind shift to work with clay in this way—and a strong arm for rolling! I have fallen in love with clay printing; it's a real crossover art from 3D ceramics to 2D format, and the ingredients are actually more affordable than gelatin printing. A few pounds of clay and a packet of powdered slip and pigments will not only provide stunning prints for small change, but hours of amazing printmaking joy too—so do try it.

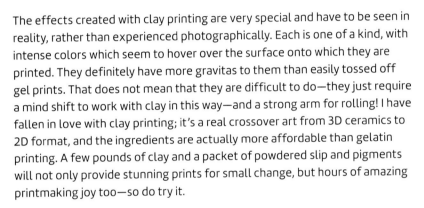

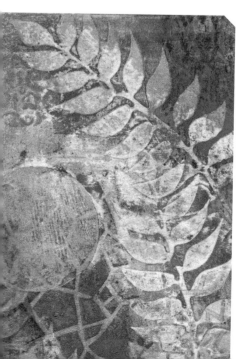

CLAY IDOLS

YOU NEED

Potter's clay—preferably stoneware from pottery suppliers (1 lb. for up to a 4½" x 5¾" slab)

Roller—brayer, rolling pin, smooth glass bottle or piece of PVC piping

Spray bottle of water

Slip—ready-made, china clay slip from pottery suppliers (or make your own using equal parts of powder to water, mixing until smooth and then sieving. These can be thinned further as you work with them for effect)

Containers, paintbrushes and squeeze bottles with nozzles for each color

Permanent pigments, oxides, stains, tempera paint powders (dry poster paints) and acrylic paint pigments will do but **not** acrylic paint, which will cause the clay to "seize" (stiffen into an unworkable lump)

Sheets of newsprint—ready-cut and stacked to roll over the print, and several small pieces for making transfers (Recycle old newspapers: the print does not affect the transfer process)

Implements for impressing texture, stencils, masks (see gelatin printing)

Colored blackboard chalk

Metal sieve

Roll of drywall tape or brown paper tape

Smooth paper or fabric for printing— spun-bonded polyester fibers are best, as they create ionic bonds with clay, which make more vibrant prints than natural fibers. (I use heavyweight, non-woven interfacing, recommended by Mitch Lyons, and cotton tearaway)

Metal spoon

Sealer (optional, as clay prints are permanent and best seen unadulter- ated—water-based matte will retain the clay finish)

1. Roll a flat slab of clay using even guides (for example, ½" thick sticks) on either side of the roller. A rectangular tray or recessed frame will also contain clay in the right shape for printing. Allow the clay to dry leather-hard. Unless clay is fired at very high temperatures, it will remain clay which can be dissolved in water. If the surface gets too dry, just spritz it with water to return to leather-hard consistency, and scrape with the edge of a ruler to smooth the surface.

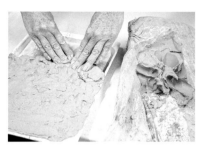

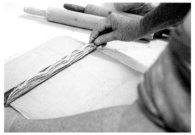

2. Divide slip in as many containers as you need colors and make one container of plain slip for coating the stoneware slab. Add a dash of pigment, stain or oxide to each color container and mix each color thoroughly with a separate paintbrush.

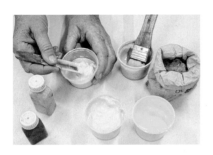

3. Apply 6 coats of plain slip to the clay bed initially—they will dry quickly and evenly. Cover each layer with newsprint and roll flat, changing direction with each layer.

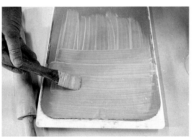

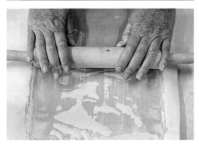

4. Apply colored slip in patterns, or abstract shapes, or build images using rollers, paintbrushes, nozzle bottles, stencils, stamps and transfers. Brush, trail, imprint and manipulate the colors.

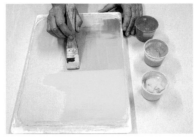

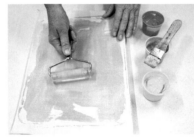

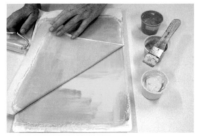

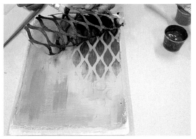

5. Make slip transfers by painting slip onto pieces of clean newsprint and letting them dry until the water glaze is absorbed. Lay coated pieces **face-down** on the clay bed, and draw or press items on the back to transfer slip to the clay.

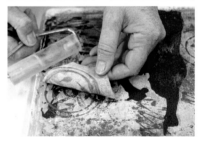

6. For a grainy effect "grate" colored chalks by rubbing them through the mesh of the metal strainer (or through stencils) onto the clay, in patches.

ALL IS GIVEN TO US AS
RAW MATERIAL, AS CLAY,
SO THAT WE MAY SHAPE
OUR ART

JORGE LUIS BORGES

7. Each time you add more slip or chalk to the bed, blot the whole bed with another sheet of clean newsprint and roll gently with a brayer (or rolling pin) to bed the color onto the clay surface.

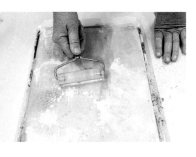

8. Before printing, mist the whole surface with a spray bottle of water and mask the edges of the clay bed with strips of drywall tape (or brown paper tape), so that the print will have clean edges.

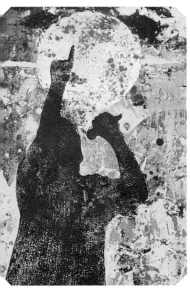

9. Mist the interfacing lightly and lay it gently over the clay bed, smoothing with your hands. Now roll from the center outward with a brayer or rolling pin. Lift a corner of the print to check transference, and keep spraying and checking until you are satisfied that the slip colors are transferring from the clay bed to the print in vibrant, velvety tones. Use the spoon to burnish the edge of the print where the tape butts against the clay surface.

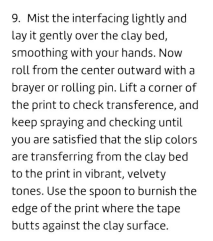

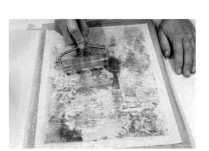

10. Lift the print by gently rolling it back on itself, and place it flat or hang to dry. You may seal these prints with any varnish, although the clay surface is permanent and beautiful on its own. I recommend water-based matte varnish to retain the clay look. However, if you like gloss or a bit of shine, consider spraying sections through a stencil—or metal-leafing parts—to add extra richness.

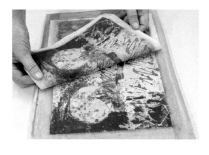

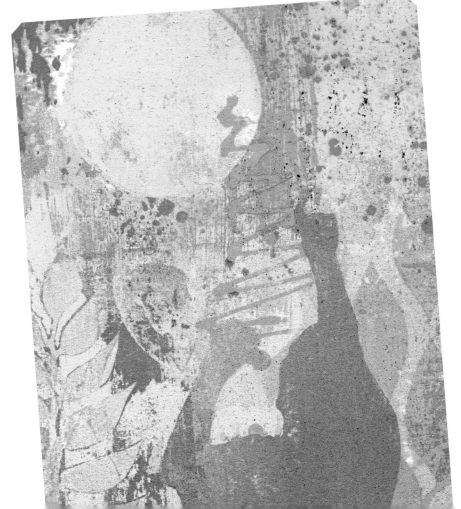

SCREEN PRINTS

Another stencil or block-out method of repeat printing uses fine mesh as a support through which to squeegee ink onto the printing surface. Screen printing is usually chosen for printing complex stencils with multiple "windows" or masks that don't have little "bridges" to connect them. The resulting prints are not obviously stenciled and multiple colors, as well as layered effects, can be achieved with good planning and accurate registration. Highly sophisticated, photographic results are possible even with homemade screens. We have covered a few methods (two of which I use often) in previous books, namely:

- **Painted nail polish screen block-out.** Nail polish, thinned with acetone, is painted onto the parts of the screen that need to be blocked out. This is suitable for small screens to produce labels.
- **Paper cut stencils.** A paper cut-out design is laid onto the printing surface, then covered by the screen mesh and ink is pulled over the screen. The paper cut-out (stencil or mask) sticks to the screen surface because of the stickiness of the ink and can be lifted and printed repeatedly before the paper starts to break up. Use thin strong paper—such as copy, freezer and baking paper—as well as contact and laminating plastic.

In *Simply Fabulous Fabric* we also explored:
- Screens prepared with silicone over powder-paint lines, which wash out, thereby exposing screen mesh through which to print.
- Starch paste as a temporary block-out, which breaks down, resulting in a whole new take on "breakdown printing" where each subsequent print allows more ink through the mesh in a random, interesting way.
- Cut batting, which is another additive method of printing, as it allows a small amount of ink to bleed through the block-out, causing more varied and random ink application.

There are many more ways to attach masks or stencils to screen mesh, but we only have space to explore one very basic hack, and three more popular methods for home printers.

However, before you begin, prepare a printing surface (see Work surfaces, page 134).

Above: Organza screen hack with duct tape

THERE IS A CONSIDERABLE AMOUNT OF MANIPULATION IN THE PRINTMAKING FROM THE STRAIGHT PHOTOGRAPH TO THE FINISHED PRINT. IF I DO MY JOB CORRECTLY THAT SHOULDN'T BE VISIBLE AT ALL, IT SHOULD BE TRANSPARENT

JOHN SEXTON

PLAIN SCREEN

A plain screen—with no fixed stencils (or resist painting or adhesions)—makes an excellent printing tool for more random prints. It can also be used successfully with paper-cut stencils or flat found stencils—such as leaves, threads, cut batting or fabric—for repeat prints. If you buy an expensive stretched aluminum screen and want to use it for multiple designs, keep it plain and use the aforementioned options. The screen is easily cleaned with water and a sponge and will be ready to use for your next project. If you go for permanent exposed resists, adhesive films and stencils, you will have the hassle of having the mesh professionally cleaned if you want to change your design—screen strippers are dangerous chemicals and working with them is not recommended for the home printer.

FAT QUARTER FERNS

Use a credit card, thickened dyes, a featureless screen and flat, found objects to whip up some fabulous fat quarters for quilting. These random prints mix colors as dye is the print medium. This leaves fabric with a soft texture after printing, which it wouldn't have with textile inks or paints. Sodium alginate is the best thickener. Follow the manufacturer's instructions to make up a paste, and divide it into separate containers for each color, adding fiber-reactive dye powder and mixing well to dissolve the colors. Printed dyes don't crack or fade and don't need to be heat-set. You will need to pre-soak fabrics in 2 tablespoons of soda ash per 2.6 gallons (10 liters) of water for 20 minutes, and air-dry before printing—do not iron as heat may turn the fabric brown. If the process is followed correctly, dye-printed fabrics are wash-fast and you can save any thickened dye for reuse if it has not touched soda ash. Use harmonious colors for a pleasing result—beware of working with complementary colors, as this will result in muddy looking overprints.

YOU NEED

Old blanket or tacky prepared work surface (see Work surfaces, page 134)

100% plain or pre-printed, light-colored, natural cotton fabric suitable for quilting—cut into fat quarters (approximately 20" x 22" squares), pre-treated with soda ash

Flat found objects—torn paper, pressed plant materials, printed organza (the designs are opaque), threads or other fibers (I used a large fern leaf)

Plain screen with open mesh

Fiber-reactive dye powder (cold water dye)—in chosen colors mixed with dye thickener

Credit card or squeegee

Extra ready-mixed alginate dye thickener

PVC gloves (optional)

Plastic sheeting—cut black plastic squares slightly larger than the fat quarters, 1 sheet per fat quarter that you print

Plastic shopping bag

Microwave

Cooler bag or insulated box

1. Smooth a prepared plain or pre-printed fat quarter over your printing surface and position your found mask **on** the cloth, in the area where you will first place the screen.

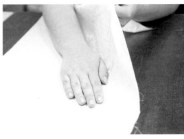

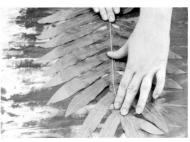

2. Drop the screen **over** the mask, blob dye on the surface of the screen and pull in any direction with the squeegee.

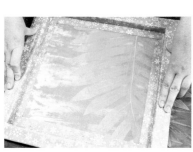

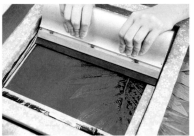

3. Lift the screen, which will now have a faint positive image of the mask on it, and pull this print on a plain or light colored fat quarter using the clear alginate mixture. Rearrange your mask each time you lift the screen if it doesn't naturally adhere to the mesh with ink—you may want to use a gloved hand to do this!

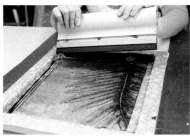

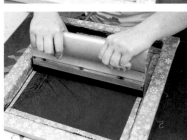

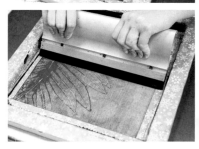

4. Place each finished fat quarter on a square of plastic and build up a layered "cake" of wet prints, interleaved with plastic. Roll into a Swiss roll shape, place in the plastic bag and microwave for about 2 minutes, then pop into the cooler bag or insulated box to batch overnight.

5. Rinse excess dye from the prints in cold water until the water looks clear. Finally, wash the fat quarters in hot water with ½ teaspoon of dishwashing detergent to remove any lingering dye—throw in a piece of white fabric to check for color fastness. Iron your unique new quilting fabrics and use them as a border for some gel prints.

PRINT OR DIE!
ANONYMOUS

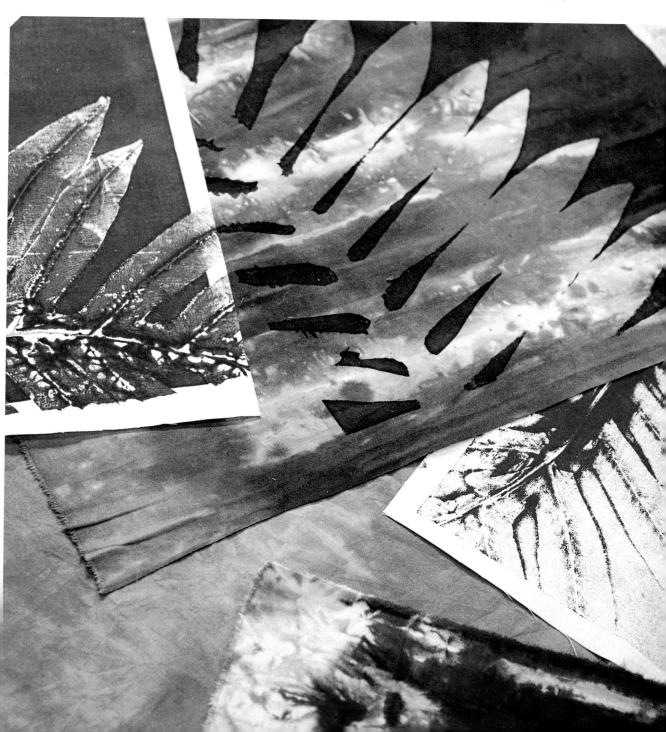

COLOR SEPARATION SCREENS

Shellac block-out screens, created the same way as nail polish block-out (see *Fabulous Fabric Paint*), are popular with art schools: the requirements are few, affordable and readily available. The only drawbacks are the time it takes to apply shellac designs on mesh, and the smelly lacquer thinners required as a solvent.

The screens last for ages—I still use 30-year-old shellac screens. This is a suitable method for repeating simple images comprising two or more colors; one screen is used per separate color.

POP ART

Andy Warhol made Pop Art multiple screen-printing popular in the 1960s, often tracing drawings from slide projections of photographs. He also used assistants to help him print various versions of celebrity portraits—among them Marilyn Monroe and Elvis. You can do the same using free photographic editing programs. Convert Image actually has an Andy Warhol Pop Art Converter, but I found another which makes it easier to print these using the shellac blocking method.

YOU NEED

Design (mine is a Pop Art styled stencil of my father—or Pop as I always called him—at age 26. I used the "Posterize" function in Google's Picasa to reduce the gray scale of an old photograph of him to two tones)

Pre-stretched screen—order online, buy readymade from a screen supplier, or make a wooden screen with nylon mesh or organza stapled tightly onto the frame (substitutes: picture frame or embroidery hoop)

Brown packaging tape—**not** masking tape (it does not stick when wet)

2B pencil

Sheet of white paper

Nylon paintbrushes

Liquid shellac (See Glossary)

Lacquer thinner for cleaning shellac brushes

Old blanket or tacky prepared work surface (see page 134)

Paper, fabric or panel to be printed— bear in mind that if using a colored rather than a white base, the colors you put over it will change according to the base

Teaspoon

Printing inks—one per screen (unless you want an adventurous swirly result!)

Squeegee or credit card—needs to fit inside the frame

An extra pair of hands!

1. Surround the outer edges of the frame with packaging tape; this will help you to block out the mesh neatly in step 2. Make sure that you leave enough space for the design. Flip the screen back over and stick packaging tape to the inside edges of the frame as well. This saves painting shellac and provides a wipe-clean surface for the ink to be laid into the well in step 3. Place the screen, **mesh-side down**, on top of the design and trace lightly

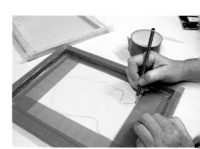

onto the mesh with pencil. Flip the screen onto white paper. The reversed design should be visible against the paper. If printing text, it should read backward.

2. Use a fine brush to paint dissolved shellac around detailed areas through which ink must pass. Hold the screen to the light occasionally to check that the shellacked parts are blocking the light. Even pinpricks of light will allow ink through, spoiling your design, so apply more shellac if necessary.

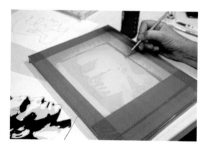

3. Use a bigger brush to cover larger areas with shellac. Clean your brushes with methylated spirits.

4. Prepare your printing surface. Mark your fabric, paper or panels to be printed with registration marks that correspond to the outer edges (or points) on the frames of both of your screens, so that you will be able to align them exactly when repeating your prints.

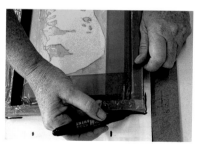

5. Position the screen, **well-side up**, and registered precisely. Spoon a layer of ink along the top edge of the well and pull the ink gently with the squeegee toward you, covering the entire exposed area of mesh with a thin film of ink. An extra pair of hands can hold the screen, or you can clamp it to the work surface. This is imperative—if it shifts, the print will smudge.

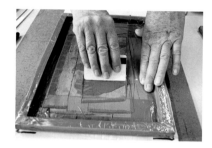

6. Lift ink from the well area close to you with the edge of the squeegee and deposit it again on the top edge. Repeat pulling the ink at an angle toward you—but more firmly this time, to work it though the mesh evenly onto the printing surface. Repeat once more.

7. Lift the screen gently from one side to the other, as though turning the pages of a book. If you pull the screen up, it may dislodge and distort the surface you are printing, which makes it difficult to register the second color correctly on top.

8. Repeat for as many prints as you want and allow these to dry thoroughly before lining up the second screen. Clean ink off the first screen while the first prints dry. Dried acrylics are difficult to remove from mesh without using toxic chemicals, so use a strong jet of cold water and a nail brush to

scrub mesh clean. Hold the screen to the light to check that the design mesh holes are open and repair any that shouldn't be. Inks may stain mesh but this is does not affect re-inking.

Note: if you're interrupted while printing, pull a thickish layer of fresh ink over the whole screen so that it doesn't dry and then resume printing later.

9. Pull the second colored print on top of the first, ensuring that the registration is exact. You can see through the mesh easily enough initially to check and mark placement, but as it becomes coated with color, it becomes increasingly important to have accurate registration markings to follow.

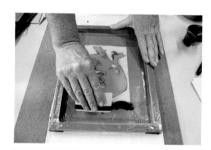

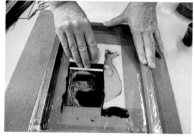

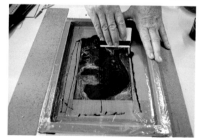

Note: My design uses two colors so I have two screens which are superimposed on top of each other with large areas overlapping.

- You can block out adjacent areas of the same design without overlapping using a screen for each separate color, but it becomes trickier to line up these layers as you print.
- I chose my design so that my second color would be dark enough to print over whatever color was laid down first.
- If you are using transparent-based ink, you need to plan for color mixing and print from light to dark.
- If you are using overlapping opaque colors, you need to work from the largest areas of color to the smallest, so that colors build over each other.
- If colors are printed in adjacent areas, opaque and/or transparent inks may be laid down in any sequence.
- If you are screen printing with textile inks or paints, remember to heat-set to enable washing.

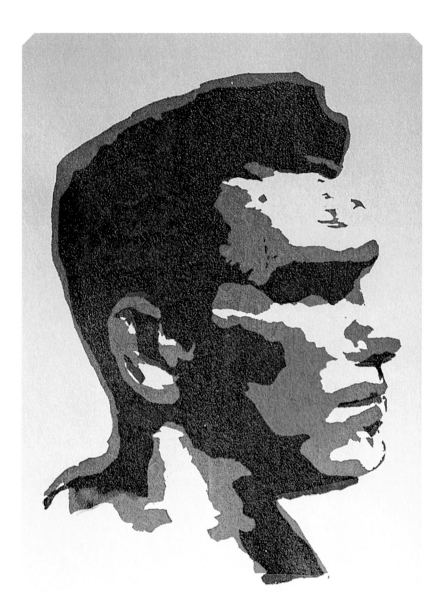

ONE OF THE ADVANTAGES OF PRINTS IS THAT THEY CAN BE EXHIBITED IN SEVERAL PLACES AT THE SAME TIME. BY THE VERY NATURE OF THEIR PROCESS, THEY ARE A POPULAR ART FORM—FOR THE MANY RATHER THAN THE FEW

ANONYMOUS

THERMOFAX SCREENS

These are made by feeding photocopies, together with a sensitizer-coated screen mesh, through a thermal imaging machine that burns off the coating where black (carbon) lines are detected, thus exposing screen mesh for ink to pass through. They are available through online suppliers who deliver exposed screens for reasonable fees. The only downside is delivery time, so plan ahead! Thermofax screens are permanent and have fixed sizes no bigger than 11" x 17". They have flat plastic or duct tape frames so they can be filed for easy, compact storage.

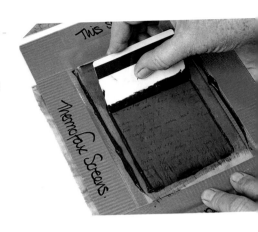

SCREEN A SAMPLER

Handmade books make ideal art journals or embroidery and gela-printed sampler albums. Like J.K. Rowling, I too never keep mine . . . I give them away all the time! Traditional books are made by stitching a collection of folded pages (signatures) to a binding or cover. Use stiffened fabric, decorated with Thermofax and other prints, to make a special book. Stitch gel printed samples onto "pages" as pockets to store messages, small stamps, die cuts and stencils (see page 131).

YOU NEED

Dyed fabric (I microwaved fabrics with onion skins, red cabbage, teabags and ferrous sulfate for muted, natural tones)

Thermofax screens (I used writing, lace and an ammonite design)

Fabric paints—use toning colors and opaque colors if the dyed fabrics are dark

Credit card

Freezer or wax paper

Glue mixture (see Accumulation art cloth page 84)

Sponge or paintbrush

1. Place the ready-dyed and cut (or torn) fabric for your book signatures onto the printing surface. Mark the centerfold to enable printing on either side so the images will be visible on the pages when they are made up.

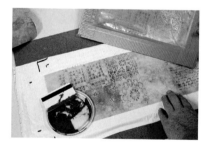

> I'VE NEVER MANAGED TO KEEP A JOURNAL LONGER THAN TWO WEEKS
>
> J. K. ROWLING

2. Make two or more prints per "page" by using the credit card as a mini squeegee with the fabric paints. Thermofax screens are ideal for small prints like these. Dry the prints (use a hairdryer for speed) before turning the fabric over and making a further two prints on the other side (**facing the same way up**). Again, dry the fabric.

3. Lay a double page across some freezer paper and paint with the glue mixture. Allow this to dry naturally, and then peel the stiffened fabric "paper" off the plastic–coated surface. Draw, write on or embellish further before stitching the folded pages together and attaching a printed cover.

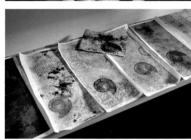

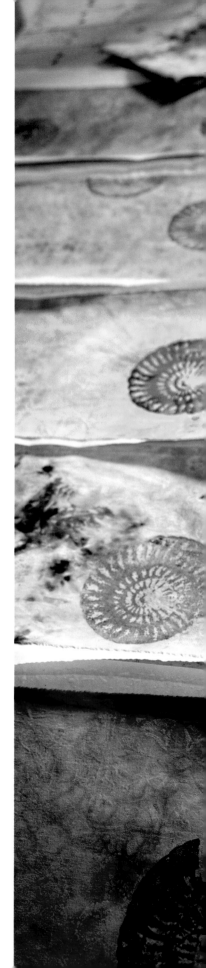

PHOTOGRAPHIC SCREENS

Screen printing suppliers will expose screens with your own custom designs for a fee, or you can buy light–sensitive emulsion and make up your own. Follow the manufacturer's instructions to create personal, highly detailed or photographic screen images from line drawings or photocopies. This method works in a similar way to Thermofax screens, except that here black or opaque designs block light (or prevent exposure), allowing the emulsion to set hard in exposed areas. An exposed screen is washed to remove unexposed emulsion before printing. Light–sensitive emulsion is a bit expensive, so work with a group and share the costs. Coat as many screens as you can and, once dry, store them covered and wrapped in black bags in a dark cupboard, ready to expose when required. Ready–mixed emulsion (in a dark container wrapped in black plastic) keeps in the fridge for up to six months.

FOX AND FELIX

YOU NEED

Pre-stretched clean screen

Light–sensitive emulsion and diazo
 sensitizer kit

Squeegee or credit card

2 pieces of black cardboard or fabric
 per screen (the same size as each
 screen or larger) and a build–up board
 (see Glossary)

Black plastic—trash bags are fine

Line design printed onto a transparency
 in the darkest ink setting on your
 printer. (If copier ink is not dense
 enough, print two designs, line them
 up exactly and tape them together.)
 Or copy or draw directly onto clear
 glass with black permanent marker

Sheet of glass same size as the screen
 or a bit larger

A sunny day or an incandescent light
 source (140W-250W)

Screen inks, fabric and printing surface
 as for the previous project

A treasured photograph of our kitten, Felix, and puppy, Carrie, enjoying a ride on the back seat of my car was easy to turn into a screen print. The original image had strong contrasting black and white tones, making it suitable to use with light–sensitive emulsion to create a photographic stencil on fine, screen mesh. I sewed the print into a customized laptop sleeve as a gift for my daughter, Lizz.

1. Organize a level work surface where you can cover the screen once coated so that light doesn't get to it before you expose your design. I hide my screen under a small table, covered completely with a dark cloth draped to the floor. Mix the emulsion and sensitising agent together as per the instructions. Squeegee the screen with the emulsion on both sides, ending with the well side. Work in low or yellow light to see what you are doing, but do not expose the screen. Set the screen to dry in the dark place, **well–side up,** and propped under each corner so

that the coated mesh is suspended above the surface beneath it. Leave undisturbed for 24 hours to dry thoroughly. After 24 hours, cover the back and front of the screen with black cardboard (or fabric) and wrap it immediately in black plastic to store in a dark place until you are ready to expose your design.

2. To expose the screen, place the printed or drawn transparency directly against the coated mesh on the **underside** of the screen. Reverse the design so it will print correctly. Cover with glass to keep it against the mesh. Now fit the screen over the dark-covered, build-up board. Do this in low (yellow) light and re-cover the screen with black card, cloth or plastic on both sides before taking it out into the light.

3. Place the covered screen "sandwich" **underside (glass-side) up** in bright midday sunshine or under a lamp. Remove the black covering from the glass and start timing the exposure. Check times for your brand of emulsion, or do some exposure tests on a spare screen, recording the results in 30 second timed stages to determine the optimal outcome. (I exposed my screen for two minutes exactly.) Cover immediately after timing so that the screen does not keep on exposing until it is washed out.

4. Wash the screen with a strong jet of water from a hose to loosen and wash away the unexposed emulsion, revealing open mesh in the parts of your design.

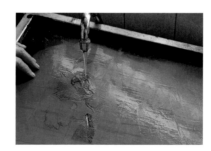

5. Let it dry thoroughly outdoors to harden the emulsion before printing as for the previous project.

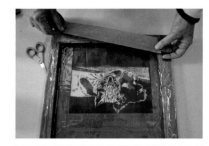

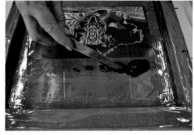

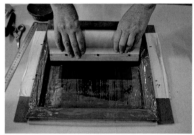

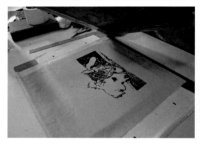

Try dragging harmonious colors across the screen for a multicolored effect on a single screen.

AND THEY CALL IT PUPPY LOVE

PAUL ANKA

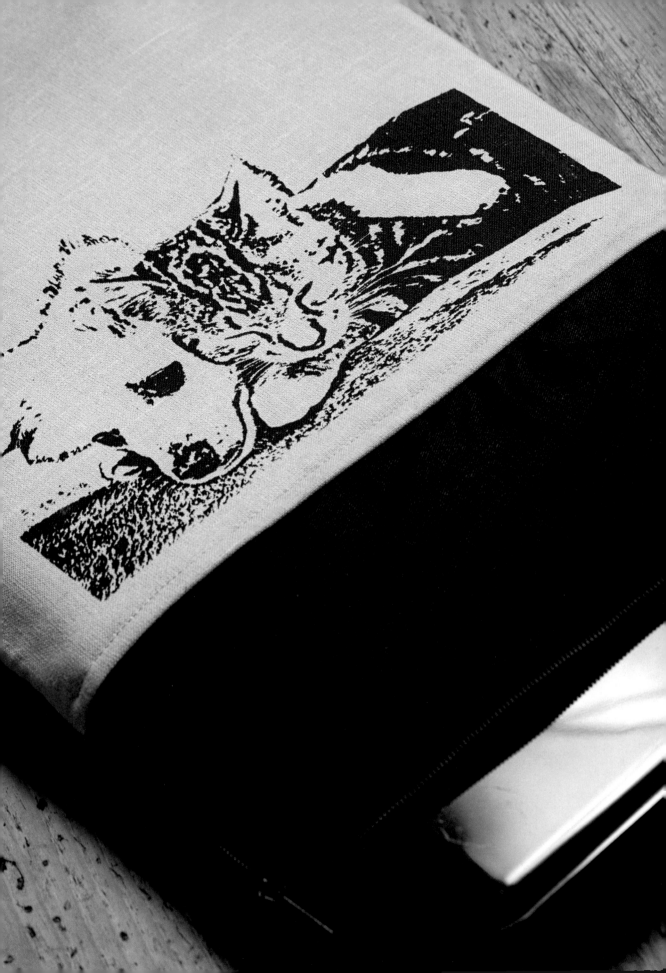

CYANOTYPE PRINTS

Have you heard of blueprints? These were developed before the invention of photocopying to reproduce architectural drawings and engineering designs on transparent vellum. Blueprints are exact negative replicas of any opaque lines or designs with characteristic white lines on a Prussian blue background. Two chemicals (ammonium ferric citrate and potassium ferricyanide) mixed together create a sepia-colored, light-sensitive fluid which is used in the semi-dark to print on paper or fabric. Once exposed to ultraviolet light, it turns the exposed areas dark, leaving unexposed areas light. When the paper or fabric is washed, the dark areas magically turn blue and the light areas white, completing the traditional cyanotype process. (There is another more stable but toxic chemical variant which is more difficult for the home printer to use.)

MAMA BLUE

YOU NEED

Cyanotype kit

2 small glass jars with tight-fitting lids, labeled for each chemical

Measuring cup and water

Sponge brush

Smooth cotton fabric or paper

Black plastic

Black piece of board and same-sized sheet of glass—larger than negative

Stencils, block-outs or a design drawn in black on a transparency or glass, or a photograph negative—use the "inverse colors" or "negative" setting in your photo editing program

Binder clips

1 part white vinegar to 5 parts water in a sink or plastic tray—half a cup per print

Hydrogen peroxide

Blotting paper

Iron and Teflon mat

Cyanotype images combine well with indigo-dyed fabrics, as the color is the identical blue. I bought an inexpensive little school science cyanotype kit at our local art and craft shop—this is a marvelous chemical reaction experiment. If you cannot find a kit, order the chemicals online—you need very little. My kit, containing ten grams of ammonium ferric citrate and five grams of potassium ferricyanide, sensitized six letter-sized sheets of paper and a yard of cotton fabric. I made some prints using a printed negative of my Mom, aged 20: a blueprint smile!

1. Dissolve each chemical in 50ml of water in the separate jars. This can be done in the light. Once you are ready to sensitize fabric or paper, you will need to work in low or yellow light (as for screen printing). Mix the two dissolved chemicals together and paint onto the fabric and paper with the sponge brush. Leave these to dry in the dark or cover with black plastic. Once dry, store in a light-safe bag.

2. In low light, place the sensitized material on the black board, covered by a stencil or block-out layer that you want printed (transparency with line drawing, leaves, lace or photographic negative) and clamp the sheet of glass over the "sandwich" with binder clips. Wrap in black plastic until you want to expose it.

3. Start timing the moment you expose the printing sandwich to light: a minute or two in bright midday sun or much longer on a dull day. Experiment. Underexposed prints wash away the blue and look very light without enough contrast—the sun didn't have enough time to fix the chemical to the print. Overexposed prints allow too much light to expose the chemicals—fine lines close up and the image becomes too blue, also without good

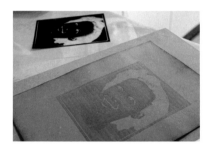

contrast. The first time I removed the negatives I thought that the process hadn't worked—the surface underneath looked blank, but in the next step I was thrilled.

4. Drop the exposed print for about 30 seconds in water and white vinegar and agitate to prevent the released color from settling and staining the image. Watch the negative develop to a beautiful blue positive. Soak face-down for a further five minutes in clean water with a dash of peroxide. Finally, rinse under running water for a minute to remove all chemicals. Try not to touch the printed area until dry. Blot carefully and hang the print to dry and intensify. Iron under a Teflon mat to set the color and flatten the print.

LET THE VISION IN YOUR HEART BE IN YOUR LIFE'S BLUEPRINT. SMILE!

OG MANDINO

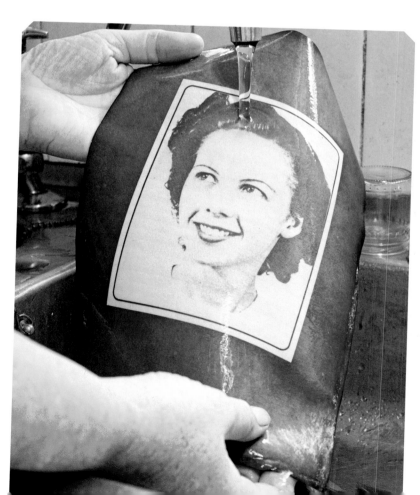

SUN PRINTS

Fabric paints diluted with water—or pigments with a liquid textile binder—also have "light-sensitive" properties when used in the sun with stencils, masks, salt and water. Sometimes sun paints are misnamed as sun "dyes." Dyes bond chemically with fibers to alter color, while paints coat fibers and are cured by heat setting. The sun sets any fabric paints exposed to it and draws moisture (together with color) away from underneath stencils and block-outs, leaving these unexposed areas much lighter, almost blank. I cut snowflake stencils (masks) from folded freezer paper. Plastic-coated paper, dark plastic film (cut from black bags) or wax paper make better contact with wet cloth than ordinary paper, which curls up as it dries, possibly spoiling the exposure. The snowflake shape produces a negative stencil or light snowflake on the darker painted background. Hygroscopic salt crystals draw moisture and dissolved color toward them, leaving light trails or wakes on the cloth. Water dropped or sprayed onto exposing sun paintings dissolves color, leaving lighter spots or pooling rings as it dries. If sun painting happens on a sloping surface, the movement of water with color will follow the slope, creating dragging patterns. Textured surfaces will throw light and shadows onto exposing color, reproducing relief and recess patterning.

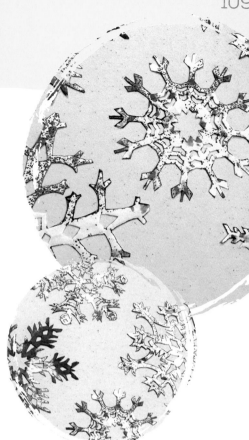

LIKE SNOWFLAKES IN THE SUN

White tablecloths gather stains so easily and I prefer to disguise them with color than try to bleach undesirable marks unsuccessfully. Sun painting is also quick when the weather is perfect: hot sun and no wind. At the coast, this is not often possible, but when conditions are right, it's the fastest, easiest way to create large impressive prints.

YOU NEED

White or light-colored fabric—100% natural fiber will print best

Dilute fabric paint (1 part paint to 3 parts water—well shaken and sieved) or buy sun paint

Sponge brushes

Snowflake stencils/masks

Coarse salt

Spray bottle of water

1. Thoroughly wet your cloth and lay it flat in a sunny, windless spot. Paint the fabric with liquid paints, allowing the colors to merge.

2. Drop more colors where you want deep hues and add water to areas you want lighter.

3. Arrange stencils or masks across the cloth. I added some snowflake confetti and die-cuts for finer details.

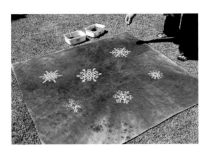

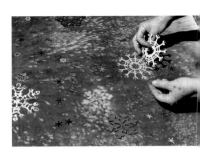

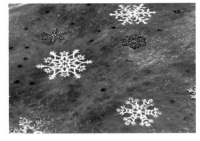

4. Drop salt crystals and spray droplets of water sparingly between the snowflakes. Walk away and let the sun do its work.

At midday my whole cloth was done in less than half an hour. Carefully shake off the stencils and salt onto a piece of paper to reuse. Too much salt will kill your grass!

I WISH I COULD PRESS SNOWFLAKES IN A BOOK LIKE FLOWERS

JAMES SCHUYLER

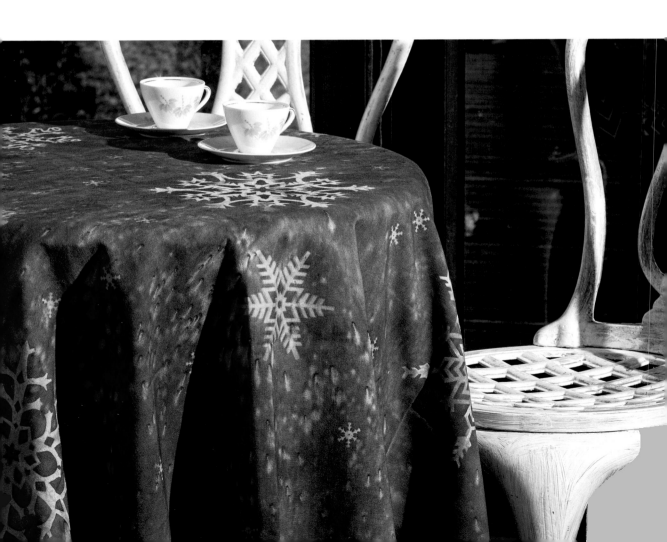

RUST PRINTS

We covered rust printing in *Simply Fabulous Fabric* but I've included an irresistible little piece to show the effects of tannin and rooibos tea on rust prints. Any piece of rusty metal will produce permanent, rich prints on wet fabric and paper. Rust tones print from light orange to dark brown, turning blue through black if soaked in teas or chemicals such as ferrous, copper and aluminum sulfates.

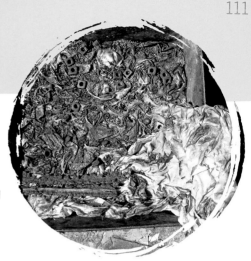

RUST PANS

I found an old muffin pan at an antique shop for 10 cents last month! It made these beautiful prints which I combined with some discharge-printed black fabric. (We also used discharge paste to print fabrics in *Simply Fabulous Fabric*.) I plan to embellish these prints further with some experimental embroidery using these and some botanical steam prints one day . . .

YOU NEED

Rusty pan or baking tray

Light-colored fabric, preferably cotton—soaked in water with a dash of vinegar

Salt

Rooibos teabags (unused) and English teabags (preferably used)

> ONE BY ONE, THEY WERE PULLED OFF THE LINES AND LEFT TO RUST IN SOME YARD
>
> FANNIE FLAGG

1. Arrange wet fabric against the rust. If the rust is patterned, smooth the fabric against it to replicate the pattern in the rust.

2. Sprinkle with salt and leave for 12 to 24 hours to develop. The fabric will continue rusting if held in contact with metal, so remove it as soon as you are happy with the print.

3. I made one print of six circles with plain rust; one with six new rooibos teabags plopped onto the fabric-covered rusty muffin bases to produce more orange prints, and

then used six used English teabags to create gray prints. New (unused) English teabags turn prints black as the tannin-to-rust ratio is too high.

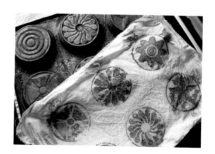

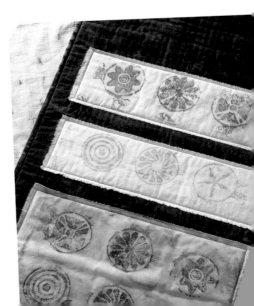

TRANSFER PRINTS

There are so many products, solvents and coated papers on the market that enable you to make photographic and other image transfer prints on all sorts of surfaces besides paper and fabric—acrylic transfer medium, acetone, transfer transparencies, disperse dyes painted on paper and freezer paper to name a few. We cover some of these processes extensively in *Simply Fabulous Fabric* and *Mixed Media* so, for a change, try transfer printing onto plaster, wood and wax, using printed transparencies and tissue paper.

PLASTER PAST

Plaster of Paris sets hard in a matter of minutes and a design can be transferred to the surface while it is still damp—so this is a good project for those of us who love to get stuff done in a hurry. The old photograph, taken more than 100 years ago, is of some of my Irish immigrant ancestors in front of their settler cottage in Colleen Glen—not far from where I live now. The original print is so fragile, making it an ideal image to preserve by scanning and reproducing it as a transfer onto something more solid than paper.

YOU NEED

2 cups plaster of Paris powder

1 cup of ice water in a mixing container (warm water will set the plaster too quickly)

Sieve

Mixing stick

Quart or half-gallon juice or milk carton—cut into two rectangular disposable molds, already waxed or foil-lined for easy release of the plaster panel, or plasticine on glass to make a mold

Piece of wire bent in a u shape and bent again for a hanging hook

Inkjet print on a transparency—sized to fit the mold

Teaspoon

Polyurethane clear matte spray varnish (water-based mediums will dissolve inkjet prints)

1. Sieve plaster slowly over the water in the container. Let it gradually wick up the water before beginning to stir the mixture very gently and slowly. Try not to introduce air bubbles or agitate the mixture, otherwise the plaster will set too quickly. Once it is an even, creamy consistency, pour it into the mold.

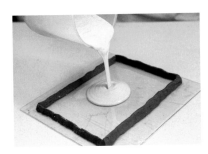

2. As the plaster begins to set, embed the bent u-shaped wire about halfway deep into the plaster—in the middle or near one end—to form a hanging hook. Leave it to set for about 4 hours before gently un-molding it onto a spongy surface (to absorb the wire protrusion on the back without cracking the plaster in the next step).

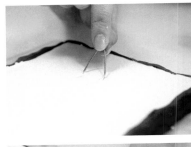

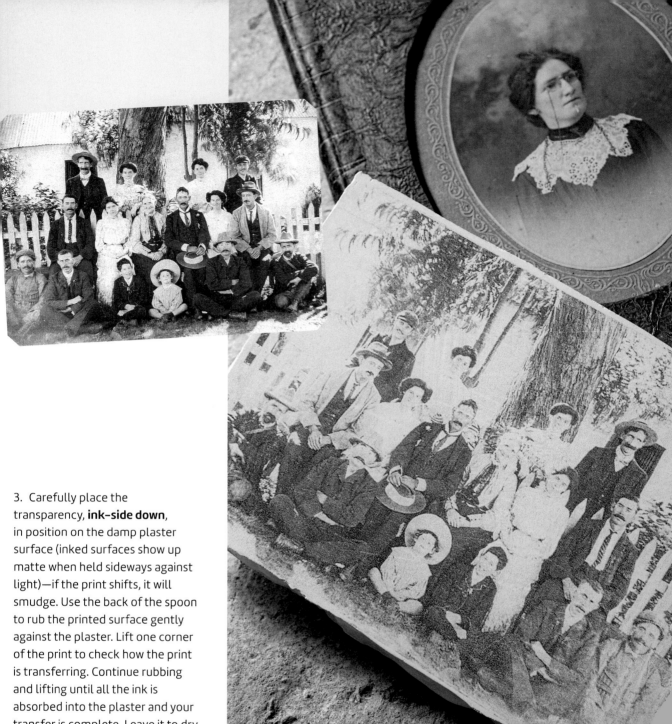

3. Carefully place the transparency, **ink-side down**, in position on the damp plaster surface (inked surfaces show up matte when held sideways against light)—if the print shifts, it will smudge. Use the back of the spoon to rub the printed surface gently against the plaster. Lift one corner of the print to check how the print is transferring. Continue rubbing and lifting until all the ink is absorbed into the plaster and your transfer is complete. Leave it to dry and spray-varnish to preserve it.

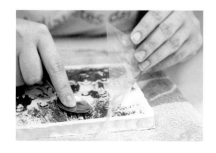

ALL MIGRANTS LEAVE THEIR PASTS
BEHIND . . . BUT ON THE JOURNEY
SOMETHING SEEPS OUT OF THE TREASURED
MEMENTOES AND OLD PHOTOGRAPHS

SALMAN RUSHDIE

WOODEN HEART

Choose a finely grained or interesting piece of plywood so your transfer shows up well. I used a black inkjet print as a good contrast with wood. This is for my neighbor, Rhona, who loves her garden so much (and for Monique who puts hearts in all our books!).

YOU NEED

Wooden board—well sanded and cut to size (approximately 25cm x 17cm)

Duct tape

Level

1 tablespoon of gelatin—dissolve in ¼ cup of cold water, then stir in ¼ cup of hot water and melt in the microwave for thirty seconds on high

Credit card

Inkjet print on a transparency

Oil- or wax-based sealer or polyurethane spray varnish

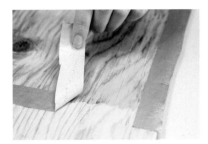

1. Frame the edges of the wood with duct tape to form a slight "well" inside the frame. Use the level to check that the wood is absolutely flat.

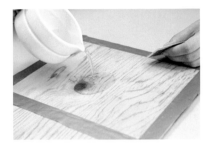

2. Pour melted gelatin into the well area, using the credit card to spread it to the edges of the duct tape frame. Let it set touch-firm—about half an hour to an hour, depending on the weather.

3. Peel away the duct tape, leaving a thin gel layer on the surface. It may have seeped a little under the tape along the wood grain—this is not a problem.

4. Lay the print, **ink–side down,** on the surface and gently smooth the back of the transparency with your hand.

5. Carefully lift a corner of the transfer and peel back the film, leaving the image on the gel surface.

6. Leave to dry undisturbed for a few days until the gel print has soaked into the wood completely. Sand the edges lightly and seal the print using a spray varnish, wood wax or shoe polish.

WHEN YOU DO SOMETHING FROM YOUR HEART, YOU LEAVE A HEART PRINT

ALICE WALKER

Upon this garden

may your stars rain down their blessed dust.

may you send rain and sunshine
upon our garden and us.

Grant us the humility to touch the soil,
that we might become more human,

that we might mend our rift
from your Creation,

that we might then know the sacredness
of the gift of life—

that we might truly experience life
from the hand of the Mother,

For you planted humanity in a garden
and began our resurrection in a garden.

Our blessed memory and hope
lie in a garden

ZEN CANDLE

Another magic transfer process uses tissue paper on a wax surface. Besides using a wax gel pad for decorative designs, I can also print fine lines or text on soaps and candles, using baking parchment transfers and tissue-paper prints.

YOU NEED

Tissue paper—ironed onto a piece of freezer paper and printed with a black line design (Zentangle) on a laser- or photocopier. (If you don't have freezer paper, glue tissue paper to a piece of copy paper, securing it around the edges only before printing)

Scissors

Pin

Glue stick

Pillar candle—round or rectangular

Wax paper

Heat gun

THERE ARE NO MISTAKES IN ZENTANGLE, SO THERE IS NO NEED FOR AN ERASER

BECKAH KRAHULA

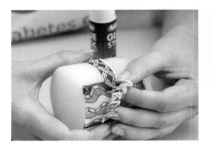

1. Cut the desired sections of print with scissors and use a pin to start gently separating the tissue paper print from the freezer paper. Peel the tissue paper carefully. If it tears don't worry—you can patch the pieces in the next step.

2. Position the cut tissue prints on the candle surface and tack in position lightly with the glue stick. Mend any tears at this stage.

3. Wrap the wax paper, **wax side facing the candle**, tightly around the candle, completely covering the design. Bunch up the excess so you have a "handle" to hold the candle. Heat with the heat gun until the wax melts—the design will suddenly look translucent. Stop immediately, allow the wax to cool and peel back the wax paper. The design will have melted into the candle surface. Repeat this process until all the tissue paper has been absorbed into the candle surface.

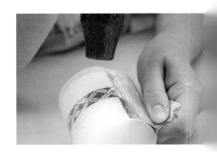

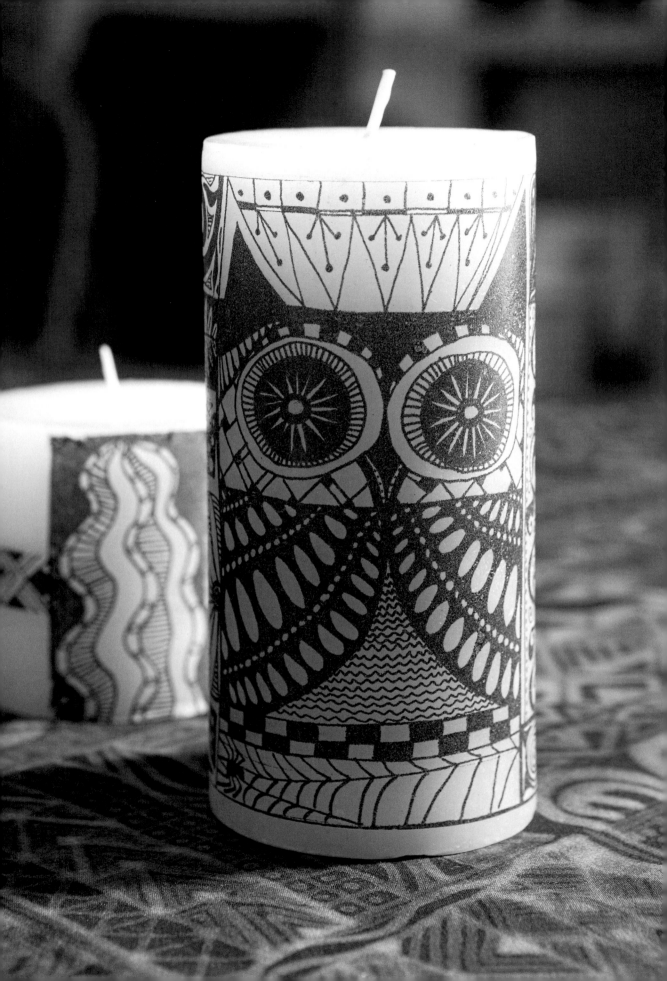

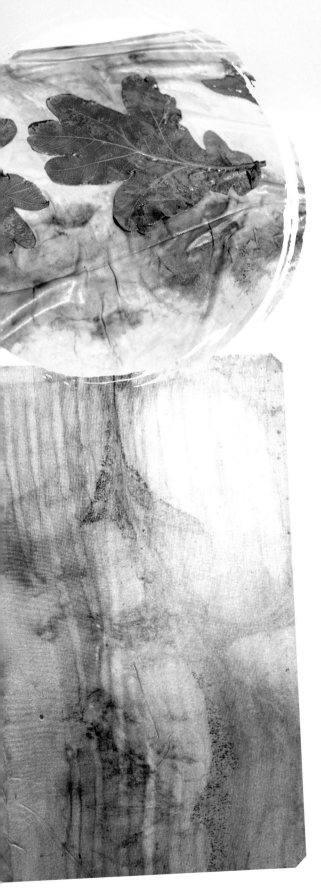

BOTANICAL STEAM PRINTS

Eco printing is a simple transfer process of steam-printing natural pigments and shapes from plant materials onto paper and fabric. It was made popular by eco-activist artists such as India Flint and Irit Dulman. To be truly ecologically sensitive, one should only use fallen or dead vegetable matter, work over an outdoor fire using rainwater to minimise energy use, and not use mordants, which contaminate groundwater. I didn't have time or space, but my results so delight and fascinate me, that I only feel a teeny bit guilty having to confess to using a microwave and municipal tap water—and flushing waste down the drain, so I renamed my process to suit my methods.

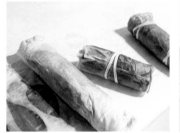
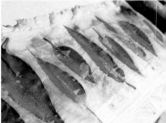

PRESSED IN TIME

I made a point of using plant materials from my own garden and street verge to print cards, silk scarves, viscose T-shirts and some handmade felt. I love these unique prints so much I find it hard to part with them as the gifts I had intended for special friends.

YOU NEED

Fabric—natural fibers such as silk, wool, cotton **and/or:**

Good quality, heavyweight watercolor paper—to withstand steaming. (I used silk scarves, 300g paper and viscose fabric)

Mordants (optional)—ferrous sulfate, copper sulfate, aluminum sulfate, vinegar, lemon juice, bicarbonate of soda or washing soda

Leaves, stalks, berries and flowers— experiment with local plants, and try pine needles, canary creeper, oak leaves, and fennel

Household bits—such as onion skins, red cabbage leaves, teabags, piece of copper pipe, rusty metal bits or steel wool

Strong elastic bands or string

2 ceramic tiles and/or cut pieces of branch or twigs

Some sticks, bamboo skewers or crumpled chicken wire

Colander (optional)

A large pot (preferably with lid)—I used a wok

1. Soften paper, fabric and plant materials by soaking them in warm water. If you want to try mordants for fixing colors (optional), you can pre-soak your materials in them, but do be aware that ferrous sulfate will dramatically darken—or even blacken—your prints, so go easy with it (½ teaspoon in ½ gallon of water is enough to start with). Blot everything thoroughly before layering plants onto the paper and fabric. Try patterned arrangements and avoid overlapping pieces.

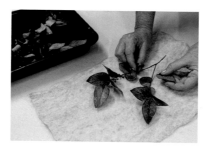

2. Roll or fold the plant materials, fabric and paper fairly tightly together, or around twigs, branches or copper pipe. Experiment with additions from your collection of household bits, and then bind the rolls with elastic bands or string. Sandwich accordion-folded selections between two ceramic tiles and bind similarly.

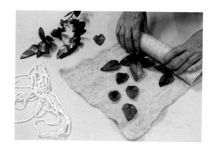

3. Suspend the tied bundles or bound tile packages in the large pot over simmering water.

EVERYWHERE I LOOKED, THERE WAS SOMETHING MORE TO SEE. BOTANICAL PRINTS, A CROSS SECTION OF POMEGRANATES, A PASSIONFLOWER VINE AND ITS FRUIT

JANET FITCH

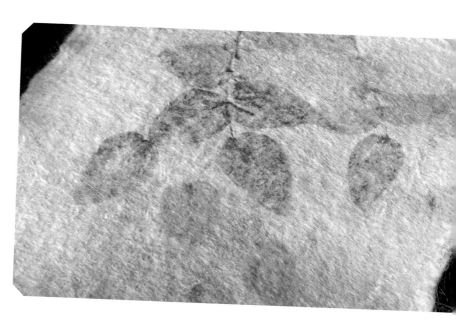

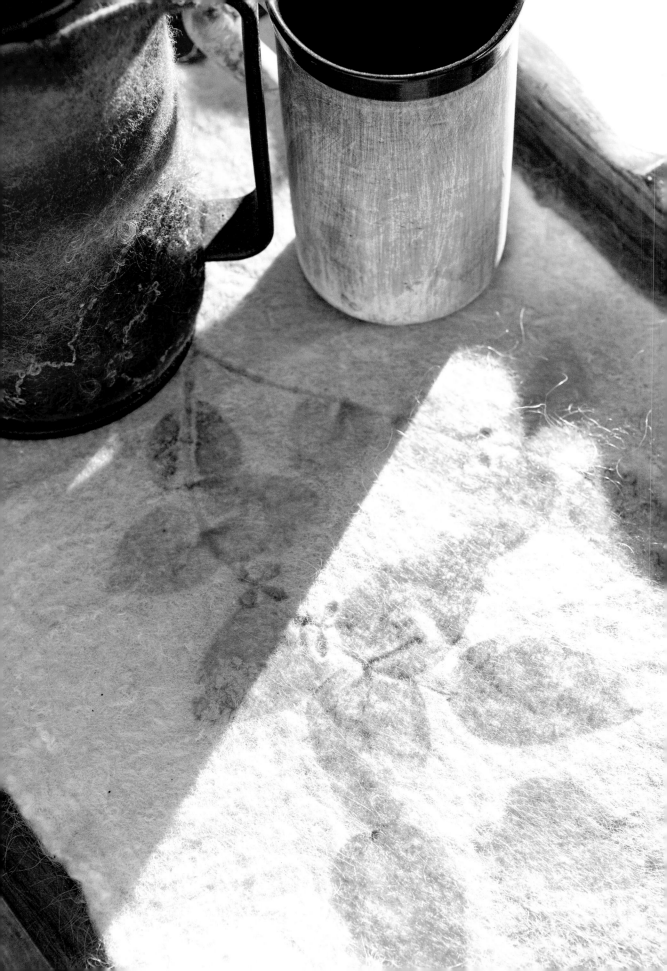

Use the colander, chicken wire or criss-crossed twigs, branches or bamboo skewers to keep everything above water level. Cover and steam from one hour to a whole day, depending on your curiosity, and ability to keep topping up the water level to avoid burning your pot dry!

4. Allow the rolled and folded items to cool completely before opening. You may also mordant now if you did not do so initially—again, the choice is yours.

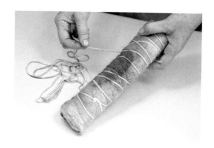
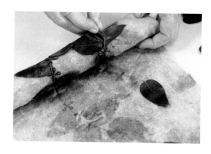

I prefer to not to mordant paper for unadulterated color transference. However, I use a teaspoon of vinegar per half gallon of water to promote light-fastness and sheen on silk, and the same amount of alum on cotton for brighter color transference. Use less ferrous sulfate to create darker prints, as the iron oxide will darken the tannins of the plant pigments.

- The results are always fascinating surprises, with that wonderful OOH factor! This is experimental printing at its most random: some leaves print through layers of materials, others only cause delicate impressions.
- Leaves or bark transfer more pigments and resin binders through their underside or transpiring surface respectively, so take this into account when planning prints.
- Colors change depending on the pH of the solution that they are steamed in or mordanted with—red cabbage is a good pH indicator as leaves and cut sections change when printed on fabric **or** paper. They turn:
 - green when moistened with bicarbonate of soda solution;
 - pink with vinegar; and
 - blue with water alone.
- Onion skins print dark yellow to orange or brown, and teabags and rust colors have already been mentioned in rust printing (page 111).
- Try using other fabrics—I printed eucalyptus leaves on some nuno felt to make a coffee pot cozy.

Below: Some of the prints that have been hard to part with!

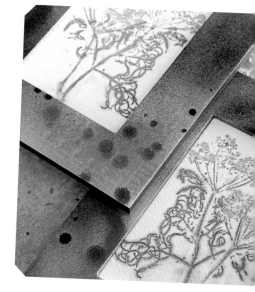

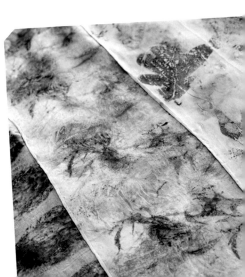

ALTERED PRINTS

Altering prints—for journaling, book-making, card-making or creating backgrounds for stenciling and stamping—is a fantastic way of generating unique backgrounds from an unending source of junk mail, old magazines and other fascinating found papers. Altered art is an exciting genre, focusing on reducing, reusing and recycling all materials.

I alter prints in many ways—most often just casually cleaning my brayer and other painting and printing tools on scrap paper. A good habit to cultivate is to roll excess or leftover mediums onto scrap, rather than washing them down the drain. Layers of color build up and eventually result in fascinating textures and tonal combinations. These provide backgrounds for yet more prints, and sometimes only need to be tweaked with a stencil or stamp to turn them into yet more works of art. (It's part of the Obsessive Clutter Disorder that thinks, "it might come in useful . . . "). Allocate a drawer or box to these pieces, and when it starts to overflow, sift through them before chucking, donating or recycling them.

Sometimes it's fun to alter a print deliberately.

GUNK ON JUNK

I look at all junk mail with new eyes and a calculating attitude: how can I use it for printing? The challenge is to make something useful and beautiful emerge from the constant war on waste.

YOU NEED

Junk mail—this colorful ad was pre-printed on beautiful, thick, recycled paper that I couldn't throw away

Stencils and masks

Stamps

Gesso

Acrylic colors that match the original print

Soft brayer, sponge, brushes

> MY MEN'S-UNDERWEAR PRINT ADS ARE VERY POPULAR!
>
> CALVIN KLEIN

1. Paint, stencil or stamp over any parts of the print that you don't like with gesso—I usually obliterate brand names and prices from advertising material but leave interesting text or images. This is additive printing gone wild.

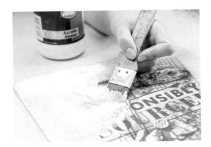

2. Paint, stamp, roll or rub colors over the gesso and printed images to integrate the background.

3. Layer stencils—or parts of stencils—over sections of the print that look bland or need more texture.

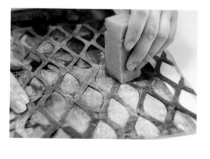

4. Use masks if you want to create fascinating windows of color and texture. Paint over them with tones and colors that contrast the material underneath them.

Try texturizing other parts of the print by printing with collagraph plates or use them as source papers for gel printing. You can go to extremes and burn holes into prints, or dissolve colors— yes, dissolve! It's great fun and produces amazing pieces of printed art.

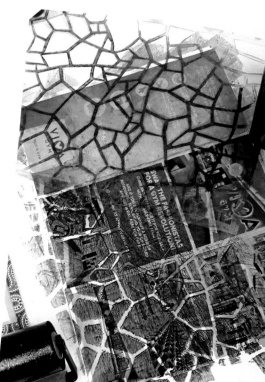

WIPE OUT

I create cards with my indigenous flower and seabird stencils; each is a unique art print worthy of framing. It is most satisfying to watch an old-fashioned printed scene or landscape dissolve into a swirl of color and be redistributed in random patterns—and through stencils—to form fascinating images.

YOU NEED

Good quality, glossy, printed paper from magazines—find old National Geographics in bargain bins (I can't bear to destroy mine unless I find duplicates)

Solvent—experiment with different solvents for different printed inks. Xylene, acetone or a more eco-friendly but equally strong, citrus-based solvent all work, depending on the printed medium (I used lacquer thinners)

Spray bottle or brush as applicator

Gloves and mask (if you are solvent sensitive)

Stencil

Paper towels

1. Spray, brush or drip solvent onto printed paper and wait as the inks begin to dissolve. Try closing pages against each other and pulling them open before the solvent dries and the dissolved ink glues the pages together.

2. Depending on how much ink has run and bled—or created "pulled patterns" on the original—decide where to place stenciled images for the most impact. Use them to remove ink: this is a fun way to play with subtractive printing.

3. Wad a piece of paper towel and roll it into a small eraser. Moisten with solvent and rub through the stencil windows. Keep rolling new erasers as each gets

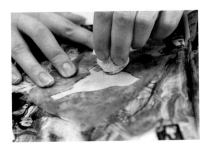

too inky to lift off more colors. Remove the stencil to see how the "negative" image looks against the textured background.

4. Replace the stencil in a light area, moisten the inky erasers with a teeny bit more solvent, and use these to dab ink **back** through the stencil areas, creating positive images.

5. Alternatively, work around masks with clean solvent, leaving the printed area under the mask undisturbed. This results in fascinating photographic images "floating" in a sea of light colored texture.

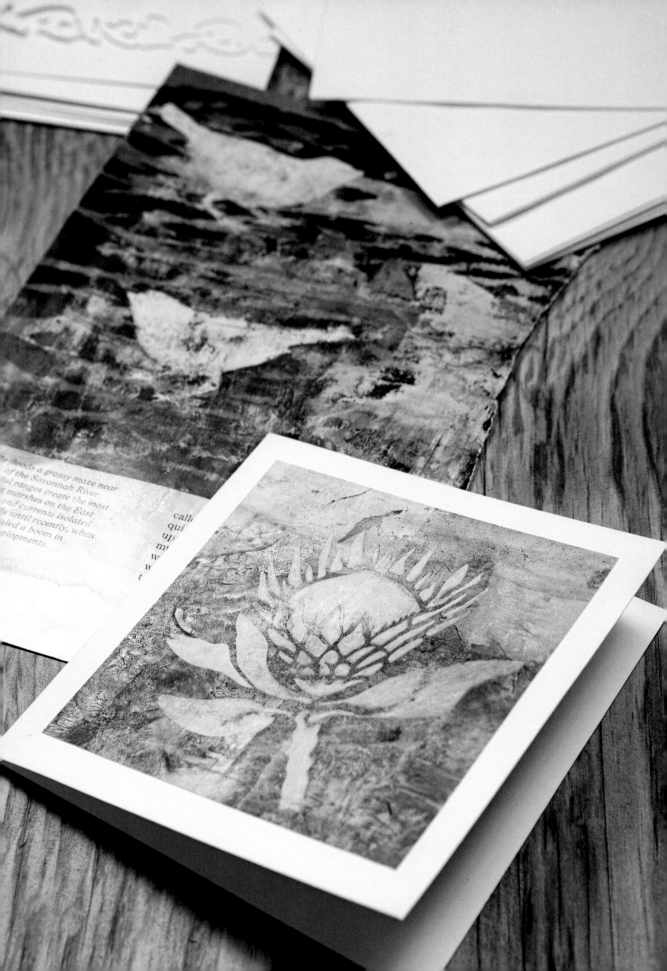

COLOR

Learn to work with color: from mixing to choosing what works, it's the most important step in gaining confidence as an artist printmaker. Experiment with intensity and contrast (tonal values), as well as hues, from monochrome to multicolors—these can dramatically alter visual impact, and take prints from being boring to beautiful, dreary to dramatic.

Play with color beyond what you like instinctively—although instinct will define your style. It's important to find out what works for you and why. Color evokes emotional responses as well as psychological stimulation. Imagine a line graphic (glue gun stencil) similar to the *Rocky Horror Picture Show* poster with undertones of the comedy horror: a red mouth on a black background, which depicts danger and darkness—it would not have the same effect if the lips were pink and the background gray.

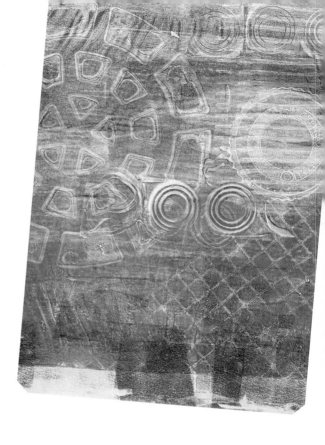

Create your own range of hues by mixing primaries with each other to see what happens. Add white or transparent mediums to lighten colors, or brown or black to darken or tone them. The best rule, besides the basic color wheel guide on the next page, is to adopt an experimental approach. "What if?" should become your guiding thought when color mixing. Being too prescriptive about color use and preferences will restrict your art and while it may define a style, can also be limiting.

I mix from the primaries used in digital printing—CMYK: cyan, magenta, yellow and black. If you have ready-mixed traditional artist colors, teach yourself how they combine with each other by painting grid charts and mixing varying amounts. Try smaller amounts of darker colors with larger quantities of light colors to keep color variations subtle. Dark colors will overwhelm light unless the light colors have an opaque base and are therefore pastel.

WHEN IN DOUBT, PRINT THE
COLOR YOU ARE WEARING
ANONYMOUS

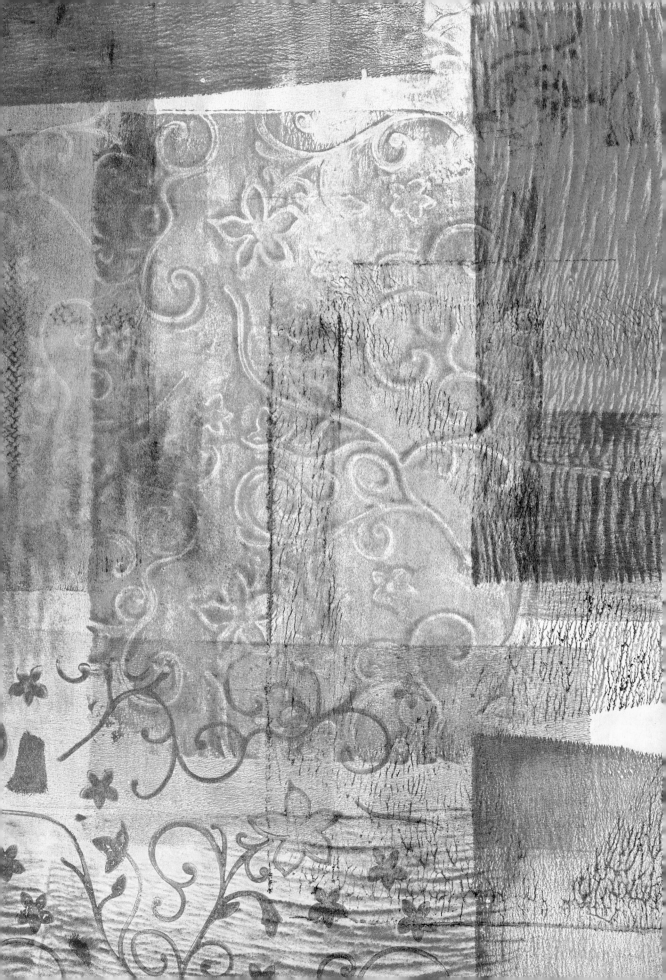

I printed the CMY letters in transparent-based colors, forming secondary colors where they overlap, instead of a traditional pie chart or "wheel." I used a small round gel pad as my "stamp" and cleaned it each time I applied a new color. These pure colors are called hues.

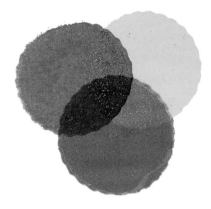

Primaries and primaries make secondaries:
Cyan + magenta = violet
Magenta + yellow = orange
Yellow + cyan = green

Primaries and secondaries make tertiaries:
Violet + cyan = cobalt
Violet + magenta = purple
Orange + magenta = red
Orange + yellow = amber
Green + cyan = jade
Green + yellow = lime

Above: Colors of gel prints decoupaged onto polystyrene blocks and antiqued

Lighten these hues with extender—or white—to create tints. A vast tonal range can be made for each, depending on the ratio of lightening medium to hue: tints of magenta range from very intense (almost pure magenta), through pinks to the palest pinky-white. Color swatches at paint suppliers are useful to collect as reference material, but don't skip the experience of doing it yourself.

Shades of colors are, strictly speaking, colors with gray tones of black added—but other darker colors can "shade" hues. For example, cyan shades to denim (or very dark blue) with black—but it also darkens more interestingly with magenta, dark blue or violet or—most surprisingly—its complementary color, orange! Colors shaded with black or gray can become lifeless or dull, so experiment with other tones for shading.

Color density, or saturation, will depend on the ratio of pigment to binder used. Intense colors have high saturation (or dense amounts of pigment) and are strong. Pale, washed-out, weak or transparent colors have low density, or saturation, and bring more light and softness to a print.

Tonal value is dependent on saturation. If colors are strong, their tone is deep and rich; weak colors create light tones. Contrast is the play of tonal values—light against dark, weak against strong—which produces dimension or texture and attracts attention.

Once you have mixed colors (lightening and shading them), you will appreciate and understand how the possibilities and permutations are endless, and how important subtle color differences are in creating a work of art—where the play of light and dark, and rough and smooth add visual depth, richness and value to backgrounds and images, thus enhancing and elevating some pieces to the level we call "art."

Earth tones are created using complementary colors: the colors which lie "opposite on the color wheel." Usually these contain the "missing" color/s from the primary trio. For example, the complementary color to magenta is green—a mix of the missing two: cyan and yellow. In the case of a secondary color which is already a mix, for example violet (cyan and magenta), the complementary will be yellow—again the missing color from the primary trio. It's always the third color completing the balance which creates the earth tone, because browns or "earth" colors comprise all three primaries. Depending on the proportions they are mixed in, a neutral range of browns through to grays is possible. Again, tints or shades of these produce beige, taupe, stone . . . Try this!

COPYRIGHT

ALL ART COMES FROM OTHER ART

JERRY SALTZ

It's easy to infringe copyright with the internet and digital home copiers enabling us to download desirable images and reproduce them in our art. Pinterest, Instagram and other sharing and storage facilities are wonderful sources of creative inspiration. As most art does start with copying in some form or other, what's the big issue?

It begins with a lack of respect for the property and livelihood of others. We need to cultivate correct attitudes toward the rights of artists, to their talents and remuneration. Piracy in the music and film industry is an international problem highlighted in the media on a grand scale. But small artists can be broken completely by theft of ideas, products and designs by others copying them directly for financial gain.

It's hard to fight this because: a) most artists are more concerned with art than financial gain, which makes it easier for the unscrupulous to exploit us; b) we are more creative than confrontational in attitude, which again allows the unscrupulous to dismiss us; and c) most struggle to earn a living from art and cannot afford to take on lawsuits to protect our rights. And while copyright laws do protect our creative output, most of us only ask for acknowledgment.

For instance: a would-be artist in our city produces many copies of works from our books for market, and while we write so that people will try their hands at all we recommend, I have a problem with her signing works with her name. As a teacher I can understand her lacking confidence in her own ideas but as an artist, I feel upset that she is earning thousands for what amounts to fraudulent work. If she was truly aware of copyright, she would not sign the work and would acknowledge her sources (and might actually owe us royalties). For every dollar she makes, we lose even more as our work becomes cheapened and loses its unique artistic value—but that's the risk we take in being creators.

I met a quilter at a craft fair in Johannesburg who used some of my designs and acknowledged her source as *Designs Galore*. Her beautiful appliqué work brought my line designs to life in their own unique way. At the same fair, another pewter artist had also adapted our work for his particular art. This is completely different from blatant duplication of an artwork or photocopying a pack of designs and reselling or charging workshop fees for them. Once you adapt a design or idea, making it your own, you are fully within your rights to sell it as your own work, but still acknowledging your design source. It's much nicer to make friends than enemies—and feel pride in your own abilities and creativity—than fall foul of copyright laws.

I had a personal experience of doing just that, unintentionally, when I wrote an article for a magazine and included captioned photographs of my own and other quilters' works. Unfortunately, the magazine failed to print the source names I had supplied, so most readers would infer the works were mine. This caused great unhappiness, and even apologies after the event were inadequate to soothe the feelings of my creative friends who were not acknowledged in the original article—and there was also the loss of potential earnings compounding the issue.

So beware the pitfalls—use all the techniques and inspiration to become bold, brave and beautiful you! (Thanks Monique—your favorite quote!)

Opposite page: The journals on the facing page were all made by different people in the same workshop with me. Each used the same batch of dyes, fabric, printing inks, selection of available stamps, textural printing materials, glues and instructions and yet each journal is as unique as its creator. There would be no copyright issues here: the personal choices, applications, positioning and finishes result in such varied and differing artworks.

Glynn's beautiful journal reflects her fine embroidery skills and sets off her exquisite handmade lace, Joan's her love of deep rich colors and botanical gel prints, Sue's penchant for the blues and greens and rubbed starch lines and Lizz's her love of stamping: owls and cats. Imagine if they were all boring, slavish copies of my original journal-making instructions and colors? All art may start with copying but interesting fine art always reflects the personality of the artist. So use your prints in special ways to develop your own particular style.

INSPIRATION GALORE

I am always inspired by the work of other artists and am both humbled and very proud to call these amazing printmakers my dear friends. I hope you will also be motivated by their work:

Janice Mendelowitz

Artist and teacher based in Port Elizabeth, South Africa. A BA Fine Art graduate and passionate printmaker since childhood, Janice uses traditional printmaking techniques, such as monotype, relief, collagraph and intaglio, sometimes individually, or in combination as hybrid prints. She prints on paper clay for 3D work and as a paper maker creates specialist books and printed body casts. Here she presents a sensitive layered monotype print.

Lillian van Aarde

Freelance fine artist based in Port Elizabeth, South Africa. A graduate of Nelson Mandela Metropolitan University majoring in printmaking, Lillian loves experimenting with mixed media, often combining traditional techniques with digital elements. This print of an octopus tentacle (inspired by a photograph by Jean-Baptiste Senegas) is a perfect example of a delicate, dry-point etching on Perspex, printed on a rolling press.

Lydia Holmes

Award-winning ceramic, print and mixed media artist based in Port Elizabeth, South Africa. She has exhibited work in galleries nationally, as well as international private collections. Her work, often humorous and whimsical, leans toward conservation issues and hides themes of human follies, hidden practices and forbidden enclaves. In these pieces, Lydia printed on leather-hard porcelain clay, using inkjet transfers dusted with stains and oxides, before firing and glazing.

THERE ARE AS MANY DIFFERENT WAYS OF MAKING
PRINTS AS THERE ARE ARTISTS MAKING THEM

KEN HALE

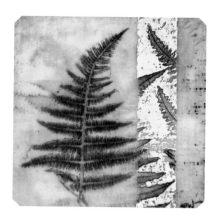

Monique Day-Wilde

My coauthor of nine books, author of *Watermarks*
and award-winning weaver and mixed media artist,
Monique resides in Pringle Bay, Western Cape,
where she teaches from her studio and runs art
retreats as well as exhibiting in many galleries. We
are both included in *The Collector's Guide to Art &
Artists in South Africa 2014*. Her roots in printmaking
techniques are reflected in her mixed-media work.
Here she presents botanical monotype prints,
layered with wax, oil paints and metal leaf.

Pam Stallebrass

BA Fine Arts, University of Natal. Pam taught art at
schools and colleges, traveling widely, and studying
in Europe, Southern Africa and South America. Her
first book, *The South African Guide to Screen Printing
Fabric*, launched my fabric decorating journey – the
two of us met 20 years later! This screen print is
inspired by both the wonderful stained glass windows
of Chartres Cathedral in France, and South African
indigenous flowers.

Cronje Lemmer

Fashion designer and printmaking artist based in
Potchefstroom in the North West Province. Cronje's
works have been exhibited as far as London, Milan,
Malta and Berlin. I fell in love with his unique
collagraphs at an exhibition 15 years ago, and was
fortunate enough to acquire these beautiful lilies.

GENERAL PRINTING GUIDELINES

Here are some very general practical observations regarding setting up, storage and cleaning:

Space

First prize is if you have dedicated studio space, but I once met an amazing lino printmaker sitting by a roadside with a knife, piece of hardboard, scrap paper, paint brush and one tube of paint! Most home printers use kitchen or dining-room tables as temporary work surfaces. I moved into our garage because the shelving racks provide easy accessibility and storage—my studio is brimming with other stuff! Gel printing requires the least space and is the most portable printing "press."

Lighting

This is all important. Depending on the type of printing, you need good, preferably non-reflective, light above or slightly behind you. Light in your eyes is distracting. Some processes require yellow light—or no light—so read project requirements and organize accordingly. A light box is a useful piece of equipment for tracing or preparing negatives. Substitutes: a large clean window pane or glass-topped coffee table with a light underneath.

Ventilation

Solvents, inks and some processes produce irritating or toxic fumes, so make sure that you have adequate ventilation. Work outdoors and dispose of solvents safely—some can spontaneously combust! Beware of drafts that cause paper and powders to blow about, resulting in mess and health hazards. In adverse weather, use a breathing mask indoors, pack away all loose items when you are finished, and open every door and window or remove yourself from the vicinity while the air clears.

Work surfaces

These vary—some printing processes need little space, others take up whole rooms. Desk tops or tables must be stable, preferably smooth (like melamine) and easy to clean. Use plastic sheeting or thick vinyl to protect home furniture. For screen printing or stamping, create a portable, padded, tacky surface by covering a board with thin foam topped with plastic sheeting or vinyl. Coat with pressure-sensitive stencil glue and cover with protective plastic for storing. This is easily wiped clean or washed and will return to being sticky when dry.

Drying

Many prints need to be dried or cured. An ironing board, fan heater, drying rack or clothesline are all useful workshop items. My beloved made two wooden peg racks, which take up little table surface and hold 68 prints back-to-back to dry. To dry flat, lay prints out of drafts, or stack pizza boxes that have been cut open on one edge as a horizontal drying rack for smaller prints. I use a wire basket trolley and some flat architectural drawers as drying racks.

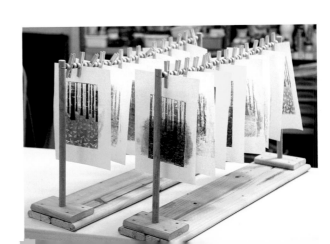

BASICALLY, ANY MATERIAL YOU CAN SQUEEZE, MELT
OR GENERATE INTO A POWDER, YOU CAN PRINT

HOD LIPSON

Tools

Keep tools in boxes, drawers, labeled shelves or hanging on a board for easy access. Clean, dry and return them to their places after use. It's easy to get very muddled without organization. Make sure cutting tools are sharp and protected from each other—stick the cutting ends into corks or erasers. Keep wires and power cords neat and coiled out of pathways. Create storage shelves, drawers, boxes or files for texture plates, stamps and stencils. Label them for easy access while in the throes of creative urgency.

Mediums

Again, ensure that everything is labeled—I have inherited bottles and jars from artist friends that are a nightmare to puzzle out. Are they oils or acrylics, poisonous or edible? Clean lids before replacing them so the bottles and tubes stay airtight. Keep oil- and water-based mediums separate, and solvents for each close by.

Storage

Testing, repeating and recycling produces great volumes of prints, which threaten to overwhelm any studio space. Try to store prints flat or rolled—but never folded. Smaller prints fit easily in large paper envelopes, plastic files, sleeves or boxes—interleaved with plain, acid-free copy paper to prevent accidental transference of color or moisture. Be sure prints are dry before labeling and filing them. I have found some stuck to others, some with smudges and even mold because I was in too much of a hurry to pack away before I had a proper drying rack—a sad waste of artwork.

Make a portfolio for larger prints. Two sheets of gray chipboard, hinged with duct tape, make a serviceable folder. Use inexpensive blotting paper sheets to separate prints from each other. Challenge: cover your portfolio with decorative prints decoupaged with wood glue. Tie closed with ribbon, stick on Velcro or large elastic bands. Portfolios slip easily behind furniture for supportive upright storage, although horizontal storage is ideal—upright portfolios can slip open, causing prints to bend or fold.

Displaying

Tack prints to walls with double-sided tape or sticky putty, or buy ready-cut mount boards from a framing supplier and tack prints in place with masking tape on the back. This works well for exhibiting. Prints can easily be removed when sold, block mounted or framed. Depending on the medium, frame or block mount prints—with or without glass or varnish to protect them. Buy readymade frames from home decorating shops and plan, print or cut printing paper to size. This is simpler and more affordable than custom framing for exhibitions or markets. Remember to edition prints (where applicable) while you do this.

Personal

Wear protective or old clothing—my aprons work overtime and besides providing protection, the pockets are on-the-go storage. Use breathing masks when applicable, gloves if you must (rubber gloves perish easily, so use PVC ones) and put talc inside to get them on and off easily. I prefer barrier cream on my hands for protection. This enables me to "feel" my art, and inks or solvents wash off my hands fairly easily.

Cleaning

Keep separate bins for recycling and waste. Reuse paper and print leftover ink onto scrap for reuse, rather than tossing. Make this a habit to reduce the amount of ink and solvents going into our drainage systems. Have a water source nearby or keep a bucket handy. Old towels are a must; use them for mopping, cleaning, drying, covering and pressing. Mine are invaluable but look disgusting, despite being washed regularly. Old dishcloths, kitchen sponges and paper towels are always useful. I recommend an orange-based spray solvent as an eco- and skin-friendly cleaning agent. It's expensive but worth it and the smell is wonderful.

Safety

Keep a first aid kit and fire extinguisher nearby. The day you run out of bandages is the day you cut yourself! Store and use cutting tools safely so you don't hurt yourself or others. I have already mentioned ventilation and wearing protective masks but I do have to stress the importance of breathing clean air: I was hospitalized two years ago for lung infarcts caused by inhaling dye and dioxins from melting plastics and solvents. I have permanently diminished lung capacity because I didn't take safety issues seriously enough.

Registration

Use a carpenter's square—a metal 90° angle—and erasable pencils, pens or chalk to plot a print pattern before you start applying your print block, stencil or screen to a surface.

Patterns vary from linear and alternating repetitions (look at brick patterns and tile layouts for ideas), through different tiling rotations, to seemingly random placement, creating overall prints and over-printed effects. When printing layers of color with separate blocks, stencils or screens, measure and mark each very accurately for exact matching or superimposing of parts when placing or composing final or composite prints.

And a few last printing hints:

- Keep lots of scrap paper handy for testing.
- Practice correct pressures for accuracy and speed.
- Plan registration before repeating prints on one substrate.
- Keep a touch-up brush and water, or solvent, within easy reach.
- Print more than you need—you can always overprint.
- Remember to reverse image and text where necessary.
- Cure or fix prints before storing them.
- Label everything!

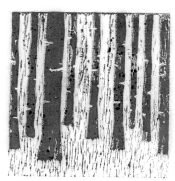
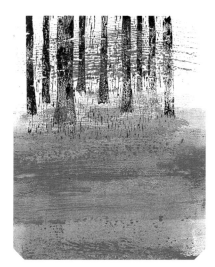

Above: Lino prints using oil-based printing inks

RECIPES

Easy homemade products save time and money.

Cold porcelain clay (air hardening)
1 part cornstarch to 1 part wood glue to 2 drops eucalyptus oil (preservative). Cook together in microwave (at 1-minute intervals, stirring in between) or double boiler until thick; knead into soft white clay, adding a little petroleum jelly to lubricate hands and make clay more pliable, and store in airtight plastic wrap until required (in the freezer indefinitely). Food or paint colors may be added into—or onto—the clay.

Gelatin pad (disposable)
Allow 2 tablespoons of gelatin to bloom per 1 cup of water; melt in microwave on high for 1 minute and pour into a level mold.

Gela pad (permanent gel printing pad)
Mix 2 parts water to 4 parts glycerin and add 1 part gelatin; allow to bloom and then microwave on high in 1 minute intervals—in a glass container—until clear; pour into a pan or mold, skim off foam with scrap paper strips and allow to set (can be refrigerated for quicker setting). Sterilize with a dash of isopropyl alcohol.

Hand sanitizer refill
Mix together and pour into a small spray bottle:
- ½ cup water
- ¼ cup isopropyl alcohol or witch hazel
- ¼ cup oil (baby, olive, almond, avocado)
- 1 tablespoon glycerin or aloe vera concentrate (not gel)
- 10 drops essential oil: clove, lavender, tea tree, peppermint

Hectograph ink (purple)
Mix 2 parts gentian (methyl) violet, 2 parts isopropyl alcohol, 1 part sugar, 4 parts glycerin, 20 parts water; keep in a dark bottle until required.

Plasticine
Melt equal parts petroleum jelly, solid neutral shoe polish, colored wax crayon and flour together in a double boiler; when cool knead well, adding more flour depending on softness required.

Printing inks:
- **Oil-based:** Mix tempera or oxide powders (and pigments—optional) with boiled linseed oil (add a little castor oil) and a few drops of glycerin to a suitable, sticky consistency. Experiment with quantities for optimal drying times.
- **Water-based:** Mix tempera or oxide powders (and pigments—optional) with water and wood glue (ratio depending on consistency required) with a few drops of glycerin until suitably sticky. Again, experiment with quantities for optimal drying times.

Stamp pads
Old CD cases containing baby wipes or high-density foam cut to size and inked.

Stamp pad inks
Mix 1 part pigment to 5 parts alcohol, and add to a mix of 3 parts water to 20 parts glycerin; if too thin, melt 1 part gelatin with the water and glycerin to thicken.

Wax gel pad (print pad for diluted oil-based paints)
Melt a kilo of gel candle wax and pour into a large baking tray to set. Use similarly to gela pad and clean with wet wipes.

Wet wipes
Cut a good quality (cheap ones will disintegrate) roll of paper towels in half; pull out the core and stuff each half into a one-quart yogurt tub with a lid. Mix 1½ cups hot water, 1 tablespoon liquid soap or body wash, 1 tablespoon oil (baby, almond or olive), 1 tablespoon aloe vera, glycerin, and vitamin oil or a few drops of essential oils. Pour into tubs for paper towels to wick up. Pull out wet wipes from center.

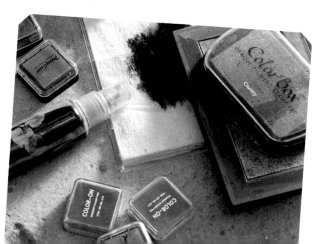

COULD AN EXPLOSION IN A
PRINTING SHOP PRODUCE
A DICTIONARY?

RUSSELL M. NELSON

GLOSSARY

Acetone: Colorless, volatile, flammable solvent for many resins and adhesives; dissolves grease, oil, and wax (substitute is nail polish remover)

Acrylic paint: Polyvinyl acetate/acrylic: water-based glue with pigment and chalk; dries to flexible plastic (water-resistant) finish

Acrylic sheets: Clear, hard plastic sheets made from polyvinyl acetate

Additive: Adding elements to something—in this case textural elements, mediums or colors to a printing plate before pulling a print

Adinkra symbols: West African symbols from Ghana

Alcohol (Isopropyl): Solvent and cleaning agent (rubbing alcohol)

Alum or aluminum sulfate: White crystalline powder, soluble in hot water with many chemical applications: a fixative or binder for dyeing or printing textiles

Ammonium ferric citrate: Green or reddish-brown water-soluble powder, acid regulating food additive also used in cyanotype printing

Appliqué paper: Iron-on release paper, coated on one side with fusible adhesive; used for cutting and sticking appliqué designs in sewing or collage

Baking paper or parchment: Heat-resistant, non-stick paper, coated with a silicone release agent

Baren: Traditional Japanese hand tool for burnishing prints; flat-bottomed disk made from layers of dried bamboo leaves with a knotted handle; commercial substitutes have tiny ball bearings to enable sensitive pressure

Batting: Lightweight layer of combed cotton, polyester or wool insulation usually used as the "filling" between two layers of fabric in quilting

Beeswax: Natural wax from bees; melts at 144 to 147°F (62 to 64°C); adhesive and covering medium in mixed media and encaustic art

Bench hook: Wooden board with fixed battens: on top as a "stop" to keep carving or cutting steady; and on bottom as a hook to grip onto the work surface

Bisque-fired: Ceramic clay-ware fired once with no water left in the clay; unglazed therefore porous

Block print: Traditional process of printing, using incised blocks

Bloom: Expand, in the context of gelatin granules

Bone folder: Traditionally bone, but now plastic, dull-edged hand tool used for creasing paper folds and burnishing sticky tape or film down flat

Book press: A screw-press for binding books

Brayer: Rubber roller: soft brayers are used for inking or applying mediums in thin, even layers; hard brayers are for pressing

Bug light: Yellow, incandescent light bulb

Build-up board: Sheet of polystyrene or wood that fits exactly into the screen well, flush with the surface, to enable stencil-positive contact when exposing screens and blocking surface-reflected light (usually black-coated or covered)

Carbon black: Black pigmented material produced by incomplete combustion of heavy petroleum or oil products; black ingredient of inks and toners

Carbon paper: Paper coated on one side with a layer of dry, carbon-based ink loosely bound with wax, enabling copies to be made with pressure from writing or typing implements

Carborundum: Silicone carbon abrasive component of sand paper, used in printmaking to trap ink in its granular composition

Cardstock: Thicker than copy paper, used for greeting and business cards, art and crafts

Carnauba wax: Very hard vegetable wax with high melting point from Brazilian palm trees; many applications, including glossy paper-coatings and making encaustic media hard and shiny

Ceramic: Any material, product or process connected with clay pottery

Chalk: Calcium carbonate or limestone: various forms are chalk sticks (blackboard and sidewalk chalk), pastels, powders and liquid "chalk" pads for similar effect

China clay (kaolin): Soft white clay; essential ceramic ingredient in china and porcelain; also used in paper- and paint-making, and many other products

Chine collé: "Tissue-glued": usually a collage of thin or delicate papers on a heavier support to enable fine, detailed printing; or a collaged background for prints; iron delicate papers to freezer paper to preserve their fragililty without gluing—they can then be peeled off the support after printing

Cold glue: See PVA or Wood glue

Collage: Assemblage of unrelated items pasted together to form one artwork

Collagraph: "Glue drawing": printmaking process in which materials are glued, or collaged, to a rigid substrate or printing plate

Contact paper or film: Adhesive paper or vinyl film (transparent or decorative) with easy-to-peel liner; adhesive may be repositionable; used as protective covering or lining

Copper sulfate: Pale green or gray-white metal salt with many uses; in intaglio printmaking for etching zinc plates; as a mordant in vegetable dyeing specifically to highlight green tints

Cyanotype: Chemical photographic printing process that produces cyan to Prussian blue prints; uses ammonium ferric citrate and potassium ferricyanide

Damar resin: Tree resin melted with beeswax to increase hardness and melting point for encaustic painting; prevents white "bloom" from forming and enables polishing

Debossed: A relief line or pattern sunk into a surface; may protrude on the other side

Decoupage: Cutting, pasting and varnishing flat images to decorate items

Deli paper: Almost transparent, slightly thicker and stronger than tissue paper, used as food wrapping; may be dry-waxed or wax-free, yet strong and porous; stands up to ink, paint and glue; popular for layering gel prints and other collage prints as mediums make it transparent

Denatured alcohol: Ethanol with poisonous additives; often purple in color; used for dissolving shellac flakes

Die cuts: Shapes cut with dies (sharp-edged, metal cutting blocks—like cookie

cutters) and a die-cutter (a press to punch cut the dies or shapes)

Discharge paste: Thick, white paste applied with brush, stamp or screen to remove areas of color from natural dyed fabrics

Disperse dyes: Water-insoluble dyes for polyester and acetate, requiring high heat to cure

Doily: Ornamental paper or fabric mat, typically with symmetrical cut-out patterns

Dry point: Lines manually scratched into print plates, producing etch-like line prints

Drywall tape: Flat adhesive tape with protective liner, used for joining sheets of drywall almost seamlessly

Duct tape (originally duck tape as in "water off a duck's back"): High-strength adhesive cloth- or scrim-backed pressure-sensitive tape, often coated with polyethylene

Dye thickener: Usually sodium alginate for thickening liquid or powdered fiber-reactive dyes for printing application

Eco-printing: Usually steam printing pigments from locally foraged plant materials onto natural fabrics or paper

Edition, limited edition and open edition: *Editions* are replicas of original designs (prints in this context); *limited* means they were produced in limited numbers and are numbered sequentially in the print process because print blocks wear out; therefore the smaller the edition, the more valuable *all* the prints; the lower the number of the edition the more valuable *each* print; *open or unlimited editions* are digitally processed as exact copies of originals and offer quality work for general affordability

Embossed: Molded or raised surface showing relief design; created with pressure by molding tools, glue or matter for relief effects (the opposite of engraved)

Emulsion: Mixture of two or more liquids that are normally non-blendable; colloidal particles suspended in a matrix

Encaustic: Hot, melted wax paint fused to an absorbent surface; wax paints composed of beeswax, resin and pigment

Engraved: Cut, carved or etched surface, using tools or chemicals for grooving lines and designs

Etching: Printmaking with designs incised (intaglio) into metal plates (usually copper or zinc) with strong acid

Exposure: The speed and amount of light allowed to reach a surface

Fabric paint: Acrylic-based paints, inks and emulsions designed specifically for use on textiles (including puff and sun paints) in transparent or opaque acrylic colors; extender or fabric paint base (medium) renders colors more transparent

Fat quarter: Quilting unit of fabric cut from a roll, usually ¾ the width (22 inches) by ¾ yard of length (18 inches)

Ferrous sulfate (iron [II] sulfate): Salt of iron or green vitriol, used among other things as a dye mordant and photographic developing agent

Fiber reactive dye: Cold water dye for coloring cellulose fibers

Filigree: Intricate, delicate, ornamental twisted design

Flocking: Small fiber particles glued to a surface for color and textural purposes; has a velvet finish

Foil and foiling: Applying foil, usually metallic; thin, film-backed material in a variety of colors and finishes; adds sparkle and interest; usually applied onto adhesive before peeling off backing

Freezer paper: Plastic-coated wrapping paper for protecting frozen foods, but with many craft applications, such as stenciling and masking: heat creates a temporary bond between the plastic coating and a paper (or fabric) surface

Fresco: Traditional mural painting technique where pigments are merged with lime plaster so that paintings become part of walls

Friction marker: Marking pen containing thermo-sensitive ink erased by rubbing or heat; exposure to cold will make markings reappear

Gel crayons: Very soft, opaque-colored drawing crayons that dissolve with water to create painted watercolor effects

Gel medium: Versatile, flexible, white acrylic medium dries clear; adds density to acrylic paint; used for transfers and sealing when applied thickly, shrinks when dry unless mixed with paint; similar properties to texture paste

Gel print: Monoprint or type pulled from a gelatin pad or plate

Gela pad: Hectograph or gelatin printing pad or plate (see Recipes, page 137)

Gelatin: Water-soluble granules or sheets of animal protein from collagen; colorless, tasteless; used in food preparation, photographic processes, hectograph and glue-making

Gesso: Gypsum and chalk with a binding medium (traditionally rabbit skin granules); primer for canvases, paper or coating wooden panels prior to painting; can add texture to water-based media

Ghost print: Print pulled from remaining ink on a printing matrix subsequent to original print

Glue pen: Ballpoint or felt-tipped pen, dispensing colored glue lines which dry clear; creates permanent bond while still wet and temporary tacky adhesive when dry; used for fine placement of small items and foil

Gouge: Chisel or dig out with a concave or scooped blade

Graded: Stepped process or color

Graphic: Clearly drawn or lettered

Graphite pencil: Pencil with graphite lead: soft, black-gray carbon with a greasy feel and metallic luster

Grid: Framework of parallel-spaced bars which cross each other, usually in rectangles or squares

Gypsum: Calcium sulfate dihydrate; main ingredient in plaster and chalk

Heat gun: Electric heating tool, similar to a hair dryer, but reaches much higher temperatures; industrial gun removes paint, melts plastics and solders; craft gun used for melting embossing powder, burning materials and shrinking plastics

Hectograph: Prepared gelatin surface (gel pad) to which original writing or design has been transferred for copying; see Gela pad

Hectograph ink: Pencils or inks containing aniline dyes, which are deposited into the gelatin surface for reprinting

Hexagon: Six-sided geometric shape

Hydrogen peroxide: Strong oxidizer, safe bleach and disinfectant; available in varying strengths from pharmacies

Hygroscopic: Able to attract and hold water molecules from a surrounding environment

Impression: Mark, print or indentation created with pressure

Incandescent: Emission of visible light by a hot object

Incised: Lines cut manually or chemically in a surface or matrix

Ink: Liquid or paste containing pigments or dyes used to color surface with images, text or designs

Inkjet print or Ink-jet printer: Digital home printer using water-based, semi-permanent ink; images only waterproof if fixed with spray fixative or clear lacquer

Instagram: Online, mobile, photo- and video-sharing, social networking service

Interfacing: Plain, non-fusible, non-woven or spun-bonded polyester; range of thicknesses from soft almost transparent to thick felt-like fabric

Inverse colors: Opposite or negative colors of a colored positive in computer image-editing programs

Journal: A record of work and reflections, usually dated

Lacquer spray: Clear spray varnish available in gloss, satin or matte

Lacquer thinners: Volatile mixture of solvents for dissolving various resins, plastics, spray paints and varnishes

Laminator: Machine to heat-weld layers of plastic film onto flat surfaces (usually paper) for protection

Laser printer: Electrostatic photocopier using toner (dry powdered ink) with heat and pressure to print paper and cloth

Leather hard: Partially dried, fully shrunk clay, can be carved into without breaking

Level: Instrument with an air bubble in a marked, clear vial of alcohol used to indicate whether a surface is horizontal (level) or vertical (plumb)

Light-sensitive emulsion: Diazo chemical (which decomposes in ultraviolet light) applied in an emulsion binder to a screen and exposed to light when dry so that exposed parts are able to harden, and unexposed can be washed out

Linear: Arranged in, or extending along, a straight line or lines

Lino block: Thick, soft linoleum (sheet-pressed linseed oil and cork) often mounted on wood blocks; incised or carved in relief with designs, images or patterns for printmaking

Lino, synthetic: A plastic or rubber lino substitute

Linseed oil: Pressed from linseeds; common base for oil paints and glazes; boiled dries faster than raw but yellows with age; artists' refined oil clearer; ingredient in traditional lino blocks

Lithographic: Stone or smooth metal plate-printing; based on principle of immiscibility of oil and water

Lutradur: Non-woven polyester fiber similar to interfacing; available in different weights and colors; can be painted, dyed, printed, stamped, stenciled, printed on with an ink-jet printer and stitched; reacts to heat, creating distressed effects as the web disintegrates into distorted fibers

Mask and masking: That which hides or blocks out

Masking fluid (aka "frisket"): Latex-rubber fluid applied as a block out or resist to (watercolor) paper to preserve paper or color underneath

Masonite (hardboard): Pressed fiberboard commonly used for construction; standard thicknesses from $1/8$" up; smooth on one side, rough side has canvas-like pattern imprinted which, when primed, makes cheap substitute for painting canvases

Matrix: Mold or mass (often metal, papier-mâché or plastic) for containing or casting positive impressions of metal type or illustrations

Mat board: see Mount board

Matte: Flat, lusterless or dull; non-reflective

MDF (medium-density fiberboard): Smooth boards, denser than hardboard or plywood, manufactured from wood fibers, wax and resin bonded at high temperature and pressure; easy to cut accurately and available in various standard thicknesses

Medium: Paint or glue type, also called a base or binder; any color or binder that can be applied to a surface; art types use specific mediums (e.g., watercolors) or mixed media (combinations of media)

Melamine: Very durable thermoplastic resin for making, among other things, laminated coatings, countertops and flooring; also a fire retardant for plastic, paints and paper

Metal leaf: Whisper-thin sheets of metallic foil (ranging from 9ct gold to Dutch metal, aluminum, copper and variegated); used with a glue binder (gilding milk or size) to add lustrous highlights to any surface; sold in booklets with tissue interleaving; fragments known as skewings; sealed with shellac or spray lacquer

Monochrome or monotone: Usually black and white or grayscale, or combinations of tones of single colors

Monoprint: Unique print, or succession of prints, from an inked or painted print plate or pad which has been altered (permanently or temporarily) with textural or line elements that persist, despite variations, from print to print

Monotype: One-of-a-kind print from a design created in paint or ink on a featureless or smooth print plate or pad

Mold: (n) Form or container used to give shape to malleable materials; (v) to shape malleable materials

Mount board (aka Mat board): Thick, strong board comprising layers of compressed paper fibers sandwiched between two thin cards; used for mounting and framing artwork; a support for mixed media or collagraphs

Needle point or tapestry canvas: Plastic grid for stitching needlepoint

Negative: Reverse order; of colors (reflecting their complementaries) or light (as dark)

Nuno felt: Japanese for "cloth" felt; lightweight, open-weave fabric that has been felted together with wool fibers

Offset printing: Where an inked image is transferred (offset) from one plate to another (often flexible) before printing the substrate

Oil paint (artist): Slow drying colors traditionally made from seed oils and finely ground pigments; differing saturations rendering variance in lightfastness and transparency reflected by codes on tubes; used in combination with drying oils (or artist-grade turpentine as thinner) for glazes

Opaque: Impenetrable or light-blocking

Original print: Made directly from an artist's own original print block or plate (or printed under artist's supervision)

Oxide: Chemical compound containing at least one oxygen atom and one other element; elemental metals or rock particles that react with acids and bases; used for coloring some paint and plaster compounds (e.g., iron oxide as brick red)

Paint sticks: Oil paint in stick form containing extra wax and drying oils; self-sealing (thin removable skin reforms with exposure) to protect paint contents; used similarly to pastels but dries permanently

Pastel: (n) Soft, intense colored crayon made from powdered pigments bound with chalks, oils, gum or resin; (a) soft, delicate tints of color, with white added

Perspex (aka Plexiglas): Solid, transparent, plastic glass substitute made of polymethyl methacrylate; easy to scratch therefore used for dry-point printing plates

Photocopy: (To make) photographic copy of printed or written material using light, heat and toner

Pigment: Natural (plant or animal) or synthetic (chemical) coloring matter

Pinterest: Web and mobile application for discovery, collection, sharing and storage of collections of visual bookmarks ("pinned" onto virtual "pin-boards")

Plaster of Paris: Fine, white form of heat-treated, quick-setting gypsum plaster; used for mold-making, casting, plastering, reinforcing or priming (main ingredient in gesso)

Plasticine (brand name): Soft, non-setting, malleable clay substitute; nontoxic so safe for children (see Recipes, page 137)

Plate-mark: Impression made on damp paper by printing plate passing through a press

Plywood: Thin layers or "plies" of wood veneer, laminated with alternating 90° grain rotation for strength

Polymer clay: Plastic, heat-hardening PVC clay used for art and craft

Polyurethane: Synthetic polymer urethane resin-based paints, varnishes, adhesives and foams; extremely hard and weather resistant; dissolved in a wide range of mineral- or alcohol-based solvents

Porcelain: Fine yet tough, strong, translucent (usually white) ceramic material (including kaolin), fired at very high temperatures

Portfolio: Sample folder of artist's work or case to display artwork

Positive: Photographic image with colors and tones corresponding to original source

Posterize: Computer imaging function for converting gradation of tone to layered planes of fewer tones; sometimes displaying abrupt changes from one tone to another

Potassium ferricyanide: Bright red, water-soluble salt of iron, potassium and cyanide; displaying green-yellow fluorescent solution with low toxicity; used in photographic print toning and blue printing; generates Prussian blue pigment

Powder paint: See Tempera paint

Printing blanket: (Usually) flexible rubber surface for transferring inked images from plates to substrates in offset printing; protective padding used in roller-press printing

Printing pad: Flexible printing matrix, plastic, rubber or gel

Printing plate: Rigid sheet of flat metal, wood, glass or plastic used as a matrix for printing

Printing press: Pressure device for transferring ink onto substrates, typically paper or cloth

Proof: Artist or printer's proof: Trial impressions to check the progress of a print in the making; not included in limited edition counts

Puff paint: Dimensional paint expanding with heat, puffing like popcorn unless blotted and ironed flat for velvety texture; matte finish can be enhanced with paints

Pull a print: Instead of saying "printing a print"

PVA (glue and paint): Polyvinyl acetate, water-based binder, with or without pigments; see Wood glue

PVC and PVC piping: Durable, low cost, chemically resistant polyvinyl chloride (plastic and vinyl); hard, chemical-resistant tubing

Quilting: Sewing or creating a quilt with two or more (usually three) layers of material for a thicker, padded effect

Recessed: Indented or set back into

Reduction print: Where mediums are removed or carved from a print plate to form a final multiple-colored design

Register and registration: Aligning prints using correlating marks that act as key for placement of prints, or connecting or overlapping colors on a single image

Relief printing: Where cut or etched surfaces of, or protrusions on, printing plates or blocks are inked; recessed areas are ink free

Reproduction prints: Prints reproduced by a printer or printing company employed and commissioned by the original artist

Resists: Various block-out mediums or impenetrable shapes used to prevent colors or glues from being applied to surfaces

Rolled felt applicator: A piece of tightly rolled felt bound with masking tape; used to apply ink

Rolling press: A printing press with one or more rollers through which substrates and print plates are fed together to print mediums or relief, in varying techniques with strong pressure

Scanner: Digital device for optical scanning of images, text or objects to convert them to digital formats

Screen filler: Blocking agent or resist painted or laminated onto a screen to prevent the passage of ink through the mesh

Screen mesh: A net of woven polyester mono- or multi-filaments (threadlike extrusions) with different thread counts per inch of weave, and varying diameter of filaments, which affect how fine a design can be printed, depending on how much ink can pass through the mesh

Screen printing: Using woven mesh to transfer mediums (particularly screen-printing inks) through stencil-blocking to print sharp-edged images on substrates

Screen-printing ink: Pigmented colors suspended in emulsion with different consistencies, capable of being squeegeed through printing mesh or screen

Sepia: Reddish-brown color tones; natural pigment derived from cuttlefish ink sac

Shade: Grayscale tones of black

Shellac: Quick-drying, UV resistant, non-tarnishing resin or varnish from lac insect secretions: flake or liquid form; solvent denatured alcohol (1 part shellac to 6 parts alcohol)

Signed print: An original or editioned print created and signed by the artist; not a reproduction print by a commissioned printmaker for the artist

Silhouette: Two-dimensional outline of an object; often dark shape against brighter background

Silicone sealer or caulking: One-part acetoxy-curing, permanent, flexible, watertight sealant, usually applied with a caulking gun

Slip: Liquid (usually china or kaolin) clay for ceramic casting or decorating

Soda ash: Alkaline chemical used for bonding dyes to fabric and photographic developing processes, among other uses

Sodium alginate: Water-soluble seaweed extract for binding, gelling or thickening;

used as a non-reactive carrier for printing fiber-reactive dye

Sodium metabisulfite: Food preservative; bleaching, cleaning and sterilizing agent used to remove excess chlorine in various industrial applications, including textile and paper manufacturing

Sodium thiosulfate: Oxygen-reducing agent used as a mordant in dyeing and bleach-stopping in textile and photographic processes

Solvent: Substance (water is most common) that can dissolve another substance, or in which another substance is dissolved to form a solution

Spatula: Hand implement with a broad, flat, flexible blade used to mix, spread and lift material or media

Squeegee: Smooth (usually rubber) flat-bladed tool used to remove or control the flow of liquid on a flat surface (e.g., applying ink onto, or removing from, screen mesh)

Stamping on, stamping off: Applying media onto, or removing from, surfaces

Starch paste: Water and flour mixture used as a paint texturizer or block-out on fabric or screens

Stencil: Thin sheet of card, plastic or metal with cut-out pattern or letters through which to apply media to reproduce the cut design on the surface underneath; usually for repeating the design

Stencil brush: Brush with round, tightly packed, head of bristles, all cut to the same level

Stencil glue (spray mount glue): Water-soluble adhesive dries tacky, enabling repositioning of items; temporary adhesion for stenciling, printing tables, photographs and picture framing; solvent for dried glue is lacquer thinners

Sticky board: A portable, padded, tacky surface; board covered with thin foam, topped with plastic sheeting or vinyl

Stylus: Small pen-shaped instrument with varying pointed tips

Substrate: Base material into which media are printed or worked

Subtractive method: Partial removal of ink with various tools from a print plate to print sections of a whole image

Sun paint or printing (aka Silk paint): Water- or alcohol-based paints (pigment dyes) in brilliant color range used on silk, viscose, cotton or watercolor paper; sun exposure develops color intensity

Superimpose: Place one layer over another so both are still evident and one enhances the other

Tannin: Plant compound that binds various proteins and acids; used as mordant in dyeing

Tearaway: White, non-woven, paper-like temporary fabric stabilizer made from cotton fibers; usually a support for embroidery

Teflon sheet: Paper thin, easy to see through, fiberglass fabric mesh sheets, Teflon-coated on both sides; non-porous to enable easy cleaning of all media; non-stick with heat tools or fusible materials

Tempera paint: Fast drying paint made from powdered pigments mixed with water-soluble binders (traditionally egg)

Template: Graphic stencil, pattern or overlay used in art and needlework to copy shapes or designs

Textile: Network of artificial or natural fibers; fabric, threads, yarns

Texture: Two-dimensional or three-dimensional surface quality; visual, actual or tactile

Thermal: Related to heat

Thermofax printing: Form of thermographic printing which relies on heat to burn images on paper or plastic-coated, heat-resistant mesh; burning off plastic coating, thus exposing mesh through which to print; process similar to screen printing exposure

Tone and tonal value: Degree of lightness or darkness of an area

Transfer: Move from one area to another

Transfer medium: Viscous glue or acrylic gel painted onto an image to absorb the ink, which is then able to be transferred from one support to another

Transparency: Thin sheet of transparent (usually plastic) film for use with an overhead projector; may be printed on with an inkjet printer unless formulated for laser copier

Turpentine (artist and mineral): Chemically based on natural turpentine (pine resin); dilutes and cleans oil and enamel paint; refined artist's variety used as a medium on its own or with artist's linseed oil for glazing or thinning oil paints; do not dispose down drains: allow sediments to settle and reuse clean liquid

Tyvek: Registered trademark of DuPont; synthetic, high-density, spun-bonded polyethylene, fibrous, paper-like material; very strong; difficult to tear but easily cut; available in sheet form in three different weights; used as paper; distorts with heat; can be printed on with inkjet copiers

Varnish: Generic term for hard, protective finish or film made from drying oil, resins and solvents; sealers ranging from mineral-spirit based polyurethanes to water-based varieties; clear, tinted gloss, semi-gloss, satin or matte (suede) finish

Velcro: Two-part hook and loop tape for binding or closing

Vignette: Small decorative design (originally vines and leaves) separating book chapters or a diffused, shaded frame for an engraving or photograph

Wallpaper glue: Cellulose-based powder that swells with water, forming a soft, non-sticky, gel-like adhesive suitable for decoupage and other paper applications; mix with diluted wood glue for strong, flexible, easy-to-work adhesive

Watercolor paint: Pigments in water-soluble gum

Watercolor paper: Wide range of artists' paper specifically designed and textured for water media; comes in different thicknesses, grades, finishes and styles

Wood glue: Multipurpose, water-based, clear-drying PVA white glue or cold glue for binding cellulous fibers such as wood, cardboard, paper and other natural fibers; variations include water-resistant and quick-drying types

Xylene: Petrochemical solvent derived from coal tar, with many industrial applications including printing; common component of ink, rubber, and adhesives; paint and varnish thinner, paraffin wax and gutta (rubber) solvent; silicone cleaner

ACKNOWLEDGMENTS

This book is dedicated with love to my mom, Tess, and late Pop, Ted Cudmore, and my beloved partner, Peter Weisswange.

Acknowledging all my loved ones and extended family in the Cudmore, Franke and Weisswange clans, especially: Peter for all your practical help, support and love, Lizz-Louise for meals and help with the photoshoot (your hands are so much prettier than mine!).

John for help with photography, Joseph for the shark collagraph, Lisa for shared enthusiasm, Margie for the marvelous letters and Gemma for lugging all those books from London!

Nkululeko Qumza for being my faithful left handyman every Wednesday.

Lise McGillivray for being my right hand during the photoshoot.

Judy Savage for being so willing to share her beautiful Bushy Park home.

My dear neighbors, the Martin family, for sharing their lovely home as a photography venue. Cadyn, you look great modeling the apron—thanks.

Also, thank you James and Wendy Wilde for agreeing that Tristan could pose in his birthday shirt—and thank you Tristan for being a star model!

FRIENDSHIP IS A WORD, THE VERY SIGHT OF WHICH IN PRINT MAKES THE HEART WARM
AUGUSTINE BIRRELL

Much gratitude also to:
Christian and Paul Marsland, Debbie Cook, Karen Francis-Gardner, Libbi Martin, Lindsay Woods (for giving me the surprise trip of a lifetime when I most needed it), Liz van Aarde (for long library book extensions, picture frames and other magic bits), Lynn Connolly (for my Gelli Plate), Rhona Nelson, Therima Behari and Zelda Wallace for keeping me going.

Our friends Anthony and Clara Klitsie, Desire Perry (for physiotherapy), Mary West, Nicky van Veesel, Kate, Rod and Sue Burton for your caring, practical and spiritual support.

The Dias Guild, Bev Paverd (fabric and indigo), Glynn Smith (embroidery journal), Graham Grimmer (for dyes), Joan Barnes (journal), Renee de Beyer, Shan Fox, Sue Bax (wood blocks and journal), Sue Hummel (Thermofaxes), and Tracey and Jenny Adams for the precious handprints.

Congratulations to Sarah Burton and Waldo Boshoff—and thanks for sharing the wedding invitations.

Thank you Lesley Deeley of Jax Wax for the generous donation of Oil Paint Crayons and Zak Qodirov of CR Printing Solutions for help and advice.

Much admiration and appreciation goes to:
Janice Mendelowitz, Lillian van Aarde, Lydia Holmes, Monique Day-Wilde, Pam Stallebras and Cronje Lemmer for your generosity in sharing work, inspiration and friendship.

The magical Metz Press team for making the most of my markings: Wilsia (thanks for believing in this book and seeing it through despite all the odds— you are a publisher in a million!), Ralf, Lindie and Nikki Metz, Deborah Morbin Procter, Monean Winterbach, Liezl Maree, Annlerie van Rooyen and last, but not least, Ivan Naudé for your patience, endurance, sense of humor, superlative work and stunning photographs. You are all special stars—and in Ivan's case a planet!

Other Schiffer Books on Related Subjects:

Beginning Illumination: Learning the Ancient Art, St *by Step*, Claire Travers, ISBN 978-0-7643-5027-6

Contemporary American Print Makers, E. Ashl Rooney and Stephanie Standish, foreword by Sus J. Goldman, ISBN 978-0-7643-4691-0

Kristy's Spring Cutting Garden: A Watercoloring Bo Kristy Rice, ISBN 978-0-7643-5335-2

Copyright © 2018 by Schiffer Publishing Ltd.

Originally published as *Prints Galore* by Metz Pres Welgemoed, South Africa © 2015

Library of Congress Control Number: 2018937054

Photography: Ivan Naudé
Cover Design: Brenda McCallum
Design: Liezl Maree

ISBN: 978-0-7643-5628-5
Printed in China

Published by Schiffer Publishing, Ltd.
4880 Lower Valley Road
Atglen, PA 19310
Phone: (610) 593-1777; Fax: (610) 593-2002
E-mail: Info@schifferbooks.com
Web: www.schifferbooks.com

For our complete selection of fine books on this a related subjects, please visit our website at ww schifferbooks.com. You may also write for a fr catalog.

I LOVE A STAR PRINT. I ALWAYS GET A LURCH IF I SEE A NICE ONE
BELLA FREUD